RMS
MAURETANIA

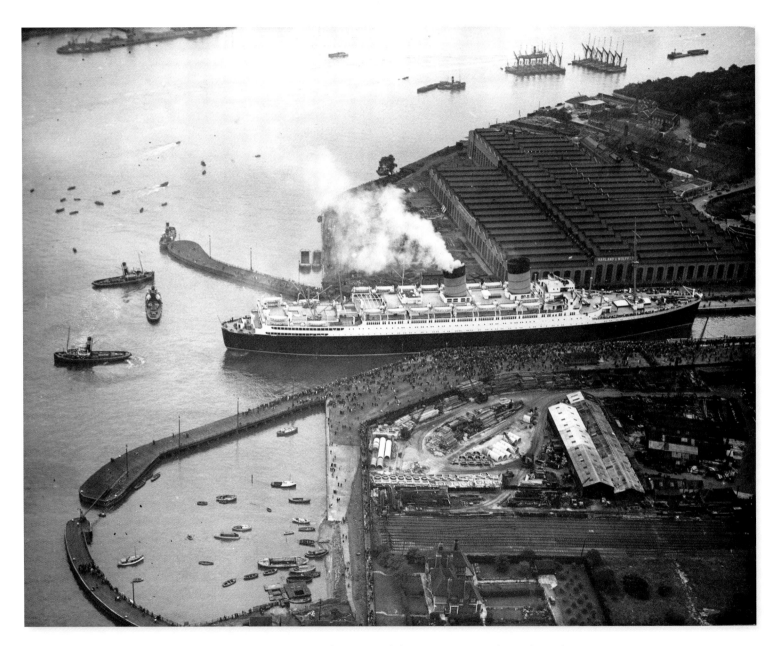

On 6 August 1939 over 100,000 people witnessed the *Mauretania*, with London pilot Harry Stowers on the bridge, squeeze into the King George V Dock in London. She was the largest vessel ever to enter the dock and this was the only occasion she did so. On 12 August 1939 the *Mauretania* left London for Southampton, Le Havre and New York, where she arrived on 18 August with 1,152 passengers. The following day the ship sailed on a six-day cruise to Nova Scotia and Bermuda. (Britton Collection)

RMS
MAURETANIA

ANDREW BRITTON

The History Press

First published 2013

The History Press
The Mill, Brimscombe Port
Stroud, Gloucestershire, GL5 2QG
www.thehistorypress.co.uk

British Library Cataloguing in Publication Data.
A catalogue record for this book is available from the British Library.

ISBN 978 0 7524 7950 7

Typesetting and origination by The History Press
Printed in India

Front cover: The *Mauretania*, in her Cunard cruising-green livery, heads down the Solent on the first part of a voyage from Southampton. (Bert Novelli/World Ship Society)

Back cover: A salute from the seagulls as the *Mauretania* sails down Southampton Water past Fawley Refinery towards the Isle of Wight. (Fricker Collection)

CONTENTS

INTRODUCTION

MAURETANIA WAS A GREAT SHIP with a magnificent historical maritime name. She lived in the shadow of her illustrious Cunard Queen sister ships. *Maury*, as she was affectionately known to many, was not built for transatlantic speed records, yet she was always considered a reliable and happy ship, which served the nation well during the Second World War. Some Hollywood film stars insisted on travelling upon her; to Lana Turner and Gary Cooper she was a personal favourite. In fact, without exaggeration, wherever *Mauretania* sailed she soon became a firm favourite: Liverpool, Southampton, London, Cobh, New York, Bombay, Sydney, Fremantle, Wellington, Freetown, Rio, Cape Town, the Caribbean – the list is endless.

I first recall seeing the *Mauretania* in her Cunard classic livery at Hythe Pier when holidaying in the New Forest with my parents and my sister. My father pointed out that a relation, Bernard Webb, was serving on the *Maury*. At first I thought she looked like a small version of the *Queen Elizabeth*, but I soon began to appreciate the subtle differences and splendour of this magnificent ship. Indeed she was to become quite a favourite, even when her livery was changed into cruising green.

More recently I met up with Bernard Webb and his brother, my uncle Joe Webb, and we reminisced about *Mauretania*. The burning question on Bernard's lips was, 'Will you write a book about my old ship, the *Mauretania*?' By coincidence I stumbled across a box of forgotten *Mauretania* original handwritten captain's logbooks, course books and original Cunard publicity paintings of the ship following the closure of the redundant Cunard facilities in New York. I decided to purchase them in order to preserve them for posterity. Once destroyed in a fire or thrown away they would have been lost forever. So the seeds for the writing of a book on the *Mauretania* were sown and as I began to speak to those who served on the ship and record their reminiscences, I discovered that she had a very proud and distinctive history. Her story is one of a very happy ship, steeped in excitement, glamour and drama, detailed here through stories told in recorded interviews, photographs from my own collection and various archives (the majority being seen in print for the first time), and sumptuous spreads of artefacts from the ship. It is a book that the reader can dip into time and again, and each time find something new about this great liner.

This book is dedicated to my son, Mark, who has encouraged its writing on an almost daily basis.

ACKNOWLEDGEMENTS

LIVING IN THE SHADOWS of the superstar liners, the *Mauretania* was often overlooked by photographers. Seeking colour slides for this book has therefore proved to be a considerable challenge. I have managed to acquire several colour slides of my own but very generous photographers and the World Ship Society have also come to my aid.

Perhaps the greatest single discovery of colour material of the *Mauretania* is due to Ciaran O'Meara of Valero Energy at Canary Wharf in London. Ciaran was the only one who had the foresight to preserve the original slides of the royal opening of the Regent Refinery at Milford Haven in 1964, in which the *Mauretania* had played a fundamental role by transporting guests and hosting the Royal Gala Dinner. This colour material has proven valuable in adding a different dimension to the images included here.

I owe a great debt of thanks to Jim McFaul and Roy Cressey of the World Ship Society for their considerable assistance in locating colour slides for this book. Southampton photographer and author Barry Eagles placed his entire collection at my disposal and I am extremely grateful to him for his help. Marianne Fricker, the wife of the late Phil Fricker of Cowes on the Isle of Wight, generously supplied Phil's original colour slides, as well as black-and-white negatives, for use in this book. I also owe a debt of gratitude to Trevor Smyth, who generously provided me with colour slides of his Mediterranean cruise of 1965 and artefacts from the ship.

Gavin Whitelaw, the owner of www.vintage-images.co.uk, responded to my appeal for assistance by sending colour images of scenes on board the *Mauretania*. I am very grateful to Gavin for his help in my hour of need.

The Australian War Memorial have been extremely helpful and not only provided detailed historical information about the *Mauretania* during the Second World War, but also sent over outstanding black-and-white photographs for inclusion in this book. I would like to express my sincere thanks to them.

The Associated Press, *Chicago Tribune*, *New York Times*, *Washington Post*, US Press Historical Images and the British *Daily Mirror* have emptied their drawers and archives to send over their original photographic prints and press copy for inclusion. This extraordinary contribution is gratefully acknowledged.

Hisashi Noma of the World Ship Society of Japan, and the World Ship Society Merseyside Branch both generously sent their black-and-white pictures of the *Mauretania* for inclusion. Oliver Hawes of the World Ship Society Ireland Branch has very generously allowed me to reproduce an original painting of *Mauretania* at Cobh.

I must express my thanks to the distinguished maritime author Gordon Turner of Canada for his assistance in providing me with additional artefacts to illustrate this book.

Former first class steward John Owens, as well as contributing his reminiscences, allowed me to scan copies of his private collection of photographs of the *Mauretania* crew. This is a most welcome contribution.

Although I tried very hard to contact former *Mauretania* engineer Terry Gleed at two different addresses in order to interview him, I was unsuccessful in tracing him. The SS *Shieldhall* Society has therefore given permission to reproduce an article originally published in their membership magazine containing Terry's reminiscences for which I am very grateful. I would also like to express my thanks to the late Commodore Geoffrey Thrippleton Marr, the late Captain John Treasure Jones, Second Officer Bert Jackson, former first class steward John Owens and former bell boy and first class steward Bernard Webb for allowing me to record their reminiscences and make notes. I only hope that I have done their memories justice. To Bernard in particular, I owe a great deal of thanks for sowing the seeds of this book.

The Southampton maritime author and modeller Nigel Robinson made me two beautiful scale models of the *Mauretania*, painted in both classic and cruising-green liveries, to help inspire me with illustration captioning. These have proved to be really stimulating when my mind went momentarily blank.

As always, my brother-in-law, Mike Pringle, has meticulously scanned and restored the slides and illustrations in this book. Additionally, Mike has photographed the original paintings, diagrams and sketches. My sister, Ruth, has transcribed the Second World War diary extracts for inclusion in this book. Their help has been invaluable.

One person who has monitored the progress of this book and proofread the text is Michael Jakeman. He has once again proved to be invaluable with his sharp eye for detail and knowledge of all things nautical.

I must say a big thank you to my wife Annette for supporting me on a daily basis when researching and writing this book and also to my sons Jonathan, Mark and Matthew for all their help.

As a parting thought, in my quest to write this book I have received generous assistance from every continent of the world – except Antarctica! A big thank you to all!

A POTTED HISTORY

DESIGN AND CONSTRUCTION

When the *Queen Mary* was launched in 1936 Sir Percy Bates, the chairman of the Cunard White Star Company, turned his attentions to improving the secondary service across the Atlantic. In April 1936 he made a clear-cut statement:

> There will always be room in the Atlantic for passenger ships of what might be called the 'second line'. And indeed the needs of the people of Liverpool and London, and other ports, make it necessary that the interests of the Company in that type of tonnage should not be neglected. I regard the first and second lines of ships not as alternatives, but as complementary to each other. Gentlemen, we need a new ship to fulfil this role.

Operating these services at the time were five Scythia class ships, six Alaunia class ships and the *Lancastria*, *Laurentic*, *Britannic* and *Georgic*. They were perceived as outdated, slow and small. What was required was a new modern liner which was larger and faster with a more luxurious ambience. This new liner would compare favourably with any ship afloat and be fast enough to act as a relief ship when either of the Cunard Queens was undergoing a refit.

Three tenders were considered by the Board of Trade for the construction of the new liner, such as Swan Hunter, Cammell Laird and Harland and Wolff. The tender price in each submission was almost the same, at around £1,775,000. After consideration the contract for the new Cunard White Star Line ship was awarded to Cammell Laird of Birkenhead as the terms of payment in instalments on completion of work were more favourable. The design specification stated that the new liner was to be approximately 33,000 gross tons, with a hull of 750ft by 89ft wide and 73ft deep, with a reasonable cruising speed of 22 knots plus a capability of extending up to 26 knots. Work on this monumental liner's construction commenced in January 1937 on what was contract No 1029, with the keel being laid on 24 May 1937.

As work progressed with the construction of No 1029, a debate raged behind the scenes over the selection of a name for the completed ship. Several possibilities were discussed including reusing the name 'Mauretania' from the legendary Cunard four-funnel, record-breaking

liner, which had been withdrawn and dispatched to the breakers in July 1935. Sir Percy Bates was not keen on the idea, but sent a telegram to Sir Ashley Sparks, the Cunard director in New York, to gauge his reaction and views. The views of Sir Thomas Royden, another Cunard White Star director, were also sought by the chairman. Sir Ashley Sparks responded, 'Referring to your telegram 7th instant – agree – think name Mauretania would be of great value.'

Sir Thomas Royden responded, '… I am content that No 1029 should be called "Mauretania".'

At the board meeting held on 20 October 1937, the name 'Mauretania' was officially approved.

Over 3,000 men were now toiling day and night until the day of the launch on Thursday 28 July 1938. The deafening noise of 2½ million rivets being hammered in to shape the plates of her hull echoed across the Mersey. Fourteen months after her hull was laid, all ten decks were completed. The cocoon of the equivalent of over 60 miles of scaffolding surrounding the hull was now carefully removed to reveal perfection. The shipyard and neighbouring houses were now dominated by the majestic sight of her freshly painted hull, which glistened in the sunlight.

The weather on the evening prior to the day of the launch was threatening to spoil the special day, with gusting gale-force winds and heavy showers blowing in from the south-west. As the sun rose on Thursday 28 July 1938, the weather calmed for what would be a perfect day with over 50,000 people packing into the Cammell Laird shipyard to witness the occasion. Lady Bates, wife of the chairman of Cunard White Star Line, proudly performed the naming ceremony, saying: 'To the ship and all who sail on her, I wish all good fortune. I name you Mauretania.'

Lady Bates gripped the bottle and flung it towards the bows. As it shattered, a splash of white spray cascaded over the platform much to the amusement of the watching Sir Percy Bates. After pressing the launch button, it took barely five seconds for the stem of the *Mauretania* to begin to drop away down slipway No 6. Within fifty seconds she was free of the slipway in the waters of the Mersey. High above, twelve aircraft circled and local tugs and ships whistled furiously to announce the birth

❯ Portrait of Sir Percy Bates, chairman of Cunard White Star Line. (Associated Press/Britton Collection)

❮ Portrait of Lady Bates, who performed the naming ceremony of the Cunard RMS *Mauretania* (II) on 28 July 1938. (Associated Press/ Britton Collection)

❯ Portrait of Robert S. Johnson, managing director of Cammell Laird. (Associated Press/Britton Collection)

❮ Portrait of Mr William L. Hichens, chairman of Cammell Laird. (Associated Press/Britton Collection)

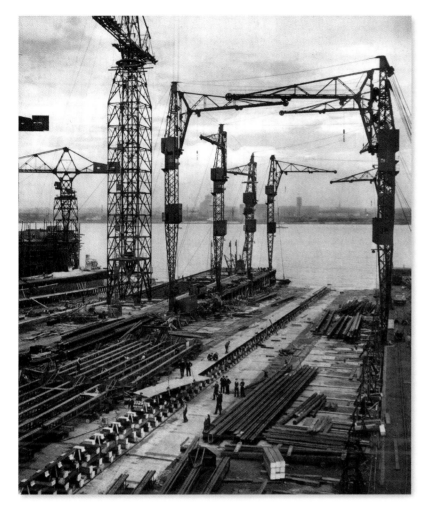

↑ The keel of the new *Mauretania* was laid on 24 May 1937. This original photograph shows one of the first keel plates being lowered and was used in the *New York Times* in early June 1937. (Associated Press/Britton Collection)

❯ Looking towards the stern, this view shows the side framing and beams of the lower decks. (Associated Press/Britton Collection)

of a great liner. While the *Mauretania* was secured for towing to be fitted out, dozens of workmen in small rowing boats gathered up the customary carpet of debris of wooden cradles and fore poppets floating in the water.

As the *Mauretania* lay motionless in the water, someone in the huge assembled crowd called out, 'Three cheers for the Maury. Hip hip …' 'Hooray,' boomed out the crowd. Henceforth the *Mauretania* was universally and popularly known as *Maury*!

An army of 5,000 workers now descended the gangplanks into the enormous hull of the *Mauretania* for fitting out. Skilled craftsmen, including coppersmiths, joiners, plumbers, electricians and carpenters, began to install heavy machinery and boilers, as well as panelling out lavish passenger accommodation using rare and expensive woods. Only the best

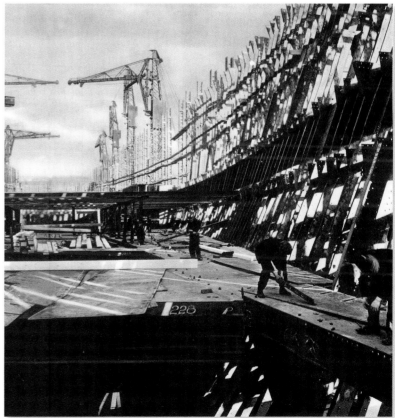

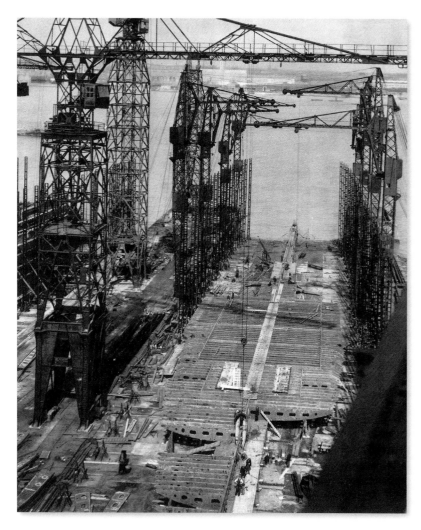

^ This view was taken from a crane and shows the cellular double bottom of the liner under construction. (Associated Press/Britton Collection)

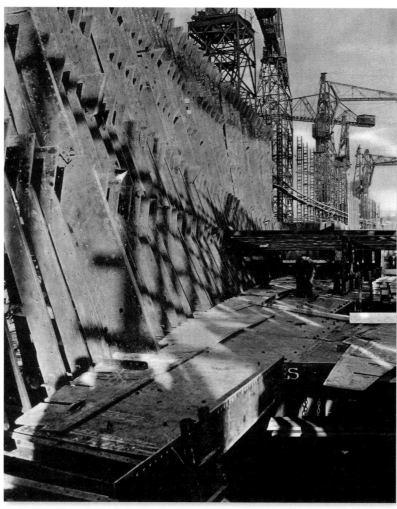

^ A panoramic view of the construction of the *Mauretania* at the Cammell Laird shipyard at Birkenhead in 1937. (Associated Press/Britton Collection)

was good enough, for the quality had to match that on the Cunard Queen liners. In the days and weeks that followed the form of a majestic liner began to rapidly appear. Plans for the final delivery date, trials and maiden voyage were now formulated.

Successful basin trials of the *Mauretania*'s machinery were carried out on 2 and 4 May 1939. She was then towed to the Gladstone Graving Dock

on 16 May where two final coats of anti-corrosive paint and one coat of anti-fouling paint were applied. At 9.30 a.m. on Wednesday 31 May 1939, the boilers were fired up gradually to full steam and the first order was given: 'Slow ahead to Liverpool Bar.' Over the next twelve hours, she now underwent steering trials and was worked up in graduated stages to full power at full ahead.

❮ The enormous cranes tower above the hull scaffolding at the Cammell Laird shipyard in 1937. (Associated Press/Britton Collection)

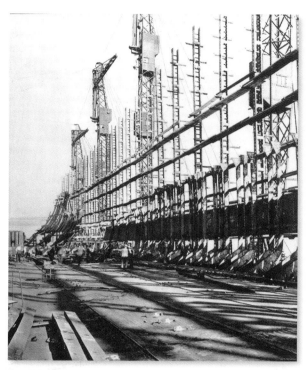

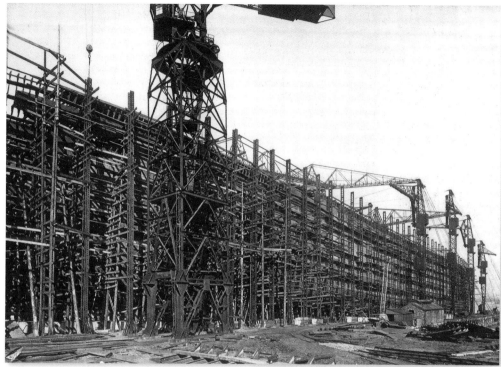

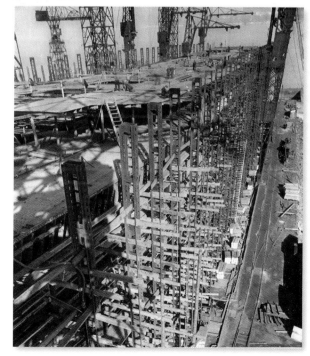

⌃ A cocoon of scaffolding surrounds the hull of the *Mauretania* at the Cammell Laird shipyard in early 1938. (Associated Press/Britton Collection)

❮ The caption in the *New York Times* of 1938 for this picture reads: 'Like a skyscraper in course of erection.' (Associated Press/Britton Collection)

❯ The 22-ton forging for a propeller shaft has been moved into place in October 1937. (Associated Press/Britton Collection)

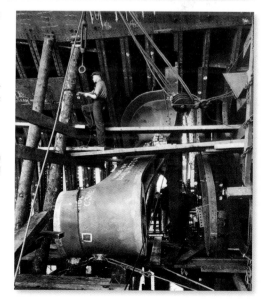

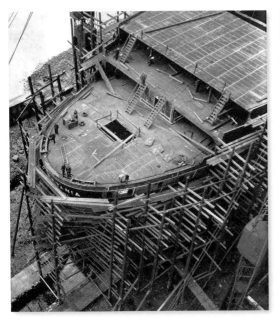

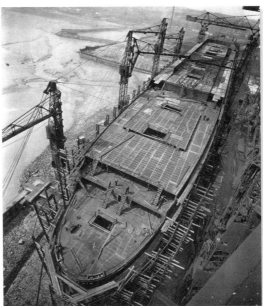

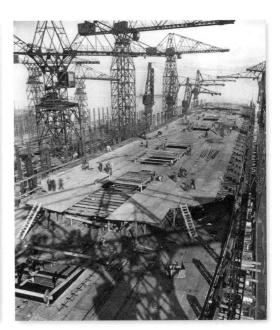

^ With launch day approaching, assembly of the aft deck is rapidly nearing completion at Cammell Laird shipyard. (Associated Press/Britton Collection)

^ The promenade deck under construction. (Associated Press/Britton Collection)

^ Photographer Stewart Bale has captured the moment to perfection in this pre-launch view showing the preparation at Cammell Laird shipyard. This superb photograph was syndicated across the USA and appeared in a number of papers. It remained forgotten in a drawer at the *New York Times* for over seventy-five years! (Associated Press/Britton Collection)

❮ A view looking along the main deck in 1937. (Associated Press/Britton Collection)

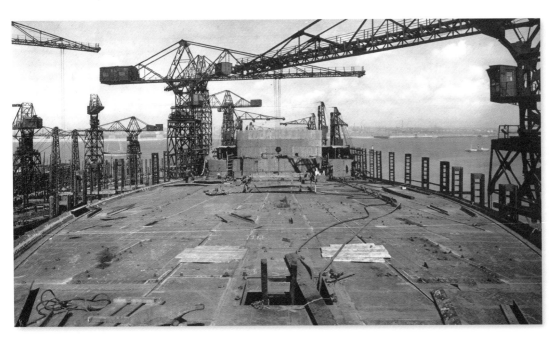

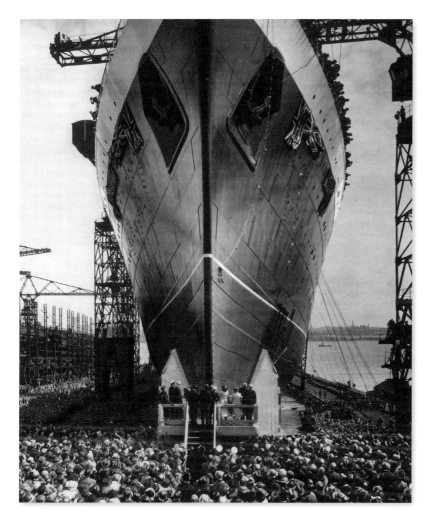

^ Lady Bates proudly unveils the name *Mauretania*. (Associated Press/ Britton Collection)

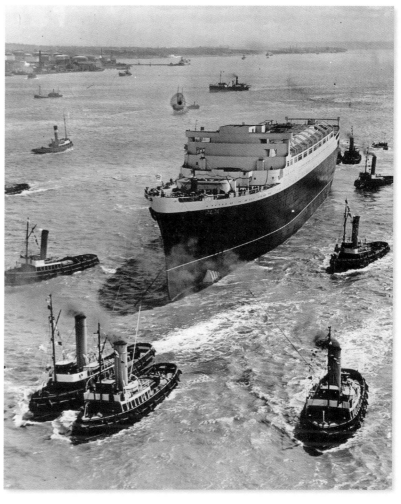

^ A flotilla of tugs escort the hull of the newly launched *Mauretania* to the fitting-out berth. (Associated Press/Britton Collection)

On arrival at the Isle of Arran, the *Mauretania* took part in five measured mile speed trials. The mean speed was recorded at 25.14 knots at 147.8rpm, confirming 47,800hp. Observations on board state that there was a little propeller noise, but no vibration, in the after part of the accommodation on the lower deck. There now followed a twenty-four-hour consumption and endurance sea trial with every movement closely monitored and detailed log recordings made. She then returned to the Gladstone Dock and docked at 12.30 p.m. on 3 June 1939 for final inspection and assessment.

At noon on 10 June 1939 Cammell Laird officially handed over RMS *Mauretania* to Cunard White Star Line. 'We have done something pretty wonderful in ship building,' Mr R.S. Johnson, the managing director of Cammell Laird, proudly proclaimed. With modifications and revisions to the agreed plans, the *Mauretania* had ended up costing £1,928,812.

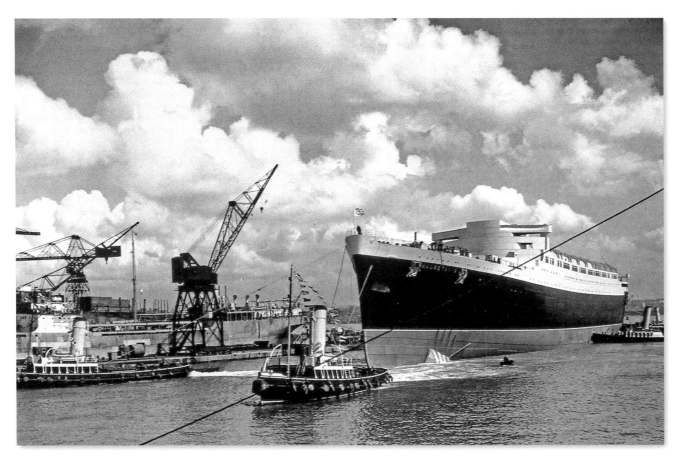

❮ The new *Mauretania* is slowly hauled by tugs from the Cammell Laird shipyard at Birkenhead to the fitting-out berth. (Associated Press/Britton Collection)

THE MAIDEN VOYAGE

The *Mauretania* sailed from Liverpool on her maiden transatlantic voyage at 7.40 p.m. on Saturday 17 June 1939 watched by over 50,000 enthusiastic cheering and waving spectators. She was dressed for the occasion from stem to stern with red, white and blue flags and accompanied by a noisy armada of tugs and small craft. Overhead three Avro Anson and Airspeed Oxford aircraft flew low in formation, waving their wing tips in salute.

The first master of the new *Mauretania* was Captain A.T. Brown, who had previously commanded the old *Mauretania* on her final voyage to the scrapyard. Now, with his smart, newly pressed, immaculate uniform and polished shining buttons, he proudly controlled every movement of

the largest ocean liner to be built in England. He was accompanied by Mr J.E. McCarthy, the veteran New York pilot who had navigated the first *Mauretania* on her maiden voyage up the Ambrose Channel into New York and accompanied her out on the final voyage.

The first part of the maiden voyage of the new *Mauretania* to Cobh in southern Ireland passed uneventfully. After a three-hour stopover at Cobh, she resumed her voyage out into the Atlantic. With nothing else but clear blue sea ahead, the *Mauretania* opened up to full ahead for the 2,912-mile voyage. Cruising at an average of 20.6 knots, the *Mauretania* arrived in New York after 141 hours and 20 minutes following a straightforward crossing. Both Sir Percy Bates and Captain Brown were said to be very pleased with the performance of the new *Mauretania*.

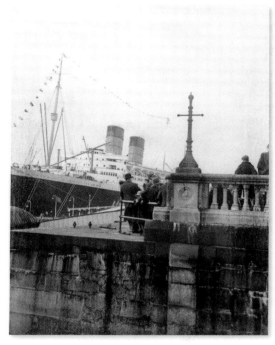

❮ The *Mauretania* heads away from the quayside at Liverpool into the Mersey estuary bound for Cobh, Southern Ireland, before sailing across the Atlantic to New York.(Hisashi Noma, World Ship Society Japan)

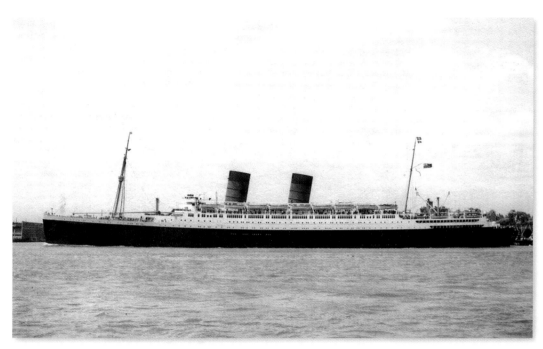

❮ ᐱ Crowds throng the quayside at Liverpool to witness the departure of the *Mauretania*. (World Ship Society Merseyside)

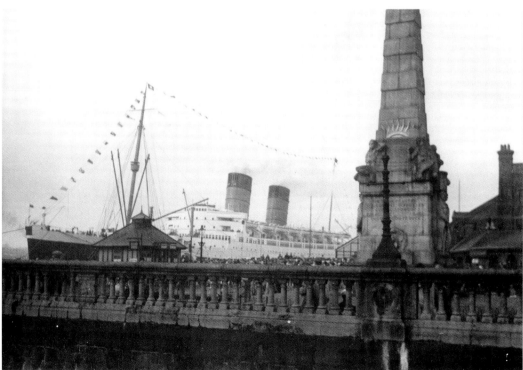

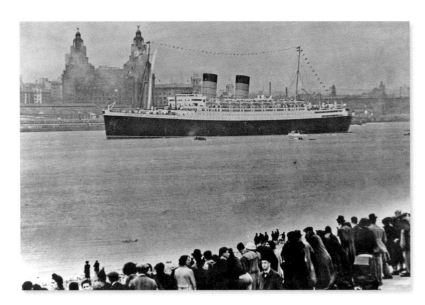

It was reported that she achieved bursts of speed of over 25 knots with an absence of any vibration. Even when the new ship encountered rough seas, she did not waiver. The only minor problem experienced was with the refrigeration system, affecting the supply of chilled water and cooling of the air-conditioning system. Whilst on her east–west maiden transatlantic voyage, she carried 1,737 tons of cargo, including £3.2 million worth of gold bullion! This was closely guarded around the clock.

˄ The new *Mauretania* sets sail from Liverpool on her maiden voyage to New York. (Associated Press France/Britton Collection)

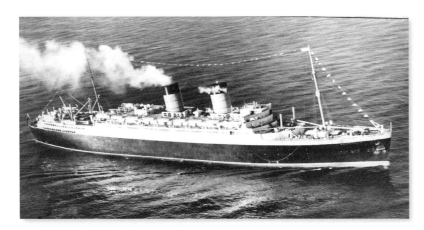

˄ The maiden voyage arrival at New York. In this aerial view the *Mauretania* is pictured towards the end of her Atlantic voyage and is approaching the Ambrose lightship. (Associated Press/Britton Collection)

❯ Pictured beneath Old Glory, the Stars and Stripes flag of the USA, the *Mauretania* approaches quarantine at the entrance to New York Harbor on her maiden voyage. (Associated Press/Britton Collection)

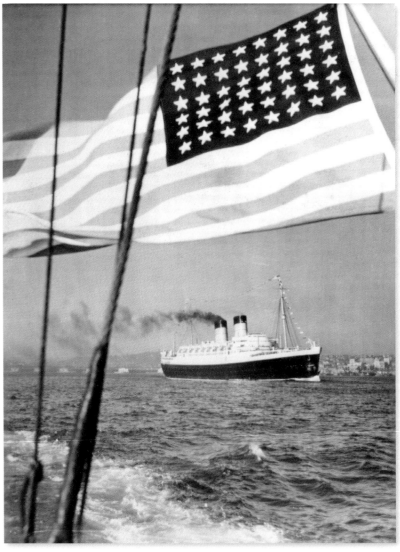

> Seven Moran Towing Co. tugs assist *Mauretania* into Pier 90 at New York on her maiden arrival. (Associated Press/Britton Collection)

˅ The *Mauretania* slowly and majestically proceeds up the Hudson on her maiden arrival. (Associated Press/Britton Collection)

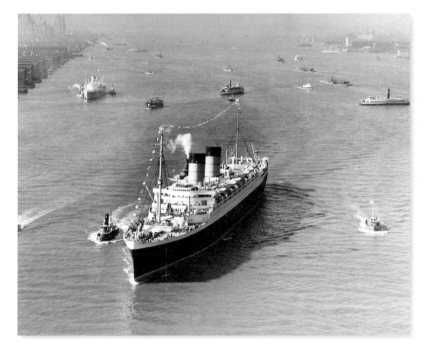

The *Mauretania* set out on the return west–east transatlantic maiden voyage from New York to Cherbourg and Southampton at 11 p.m. on Friday 30 June. Although the ship achieved an average speed of 22 knots for the crossing, she encountered more severe weather. This caused the ship to pitch and roll 5 degrees to port and 2 degrees to starboard. Some propeller vibration was also encountered.

The arrival of the *Mauretania* at Southampton at 1.30 p.m. on Friday 7 July was greeted by a crowd of thousands, cheering and waving along the shores of Southampton Water. Once safely docked, the new ship was thoroughly checked over for faults and snags. According to surviving crew members, considerable lubrication oil was added to the reservoirs to replenish that consumed on the maiden voyages. This was said to be normal after what was in effect a period of running-in for new machinery.

On the second voyage, the *Mauretania* headed up the River Thames on 6 August 1939 watched by over 100,000 people. With only 10ft 6in to spare (just 5ft 3in either side), at a snail's pace, she carefully squeezed through the King George V entrance – the largest vessel ever to enter the Port of London! Upon clearing the narrow entrance the gigantic steam whistles boomed out three times echoing across the capital to be clearly heard at Buckingham Palace and Big Ben. Crowds broke out into spontaneous applause and cheered. The new *Mauretania* was now ready to assume her position working alongside the Cunard White Star Line *Britannic* and *Georgic* on the London–Le Havre–Southampton–Cobh–New York service. However, the celebrations were short-lived as the German Führer, Adolf Hitler, had other intentions that changed the destiny of the new *Mauretania*.

SECOND WORLD WAR SERVICE

The *Mauretania* set out from New York to London on Saturday 26 August 1939 with the international situation worsening by the hour. Five days out in the Atlantic, a message was received from Cunard White Star: 'Proceed to Southampton at all haste where the voyage will terminate.' This was to be a wise decision, for the following day Panzer divisions invaded Poland and on 3 September British Prime Minister Neville Chamberlain declared war on Germany.

The next scheduled sailing of the *Mauretania* on Thursday 7 September was cancelled. Preparations were made to repaint her into matt grey livery and black out her portholes. Southampton King George V dry dock painter Fern Bussell felt it was a criminal act to paint over the new pristine Cunard paint work, but it was vital to camouflage the ship. Two 3in anti-aircraft guns and one 6in gun were mounted on her aft decks and discreetly covered in tarpaulins. Anti-flash cowling was added to her two funnels to prevent attraction from the Luftwaffe. With this basic work complete, she set sail with 698 passengers to New York on 14 September 1939.

On 15 September 1939 William Joyce, alias Lord Haw-Haw of the German radio propaganda programme *Germany Calling*, announced to the British nation that German U-boats had sunk the liner *Mauretania* whilst she was cowardly trying to escape. This was a complete lie of course, which was quickly disclaimed by the BBC.

On returning to Liverpool on 7 October, the *Mauretania* was tied up at the Gladstone Dock pending a decision on her future. Again Lord Haw-Haw announced, 'Here is an item of shipping news. The new Cunard liner *Mauretania* has just docked in Liverpool instead of Southampton.'

According to Robert Thelwell, who was then the first officer of *Mauretania* (later to become commodore of the Cunard Line), the Liverpool bar in which he was drinking went silent when Haw-Haw made his announcement:

Everyone in the room was transfixed. Conversation stopped. Men lifting their glasses to their lips stopped. The tills were silent and the barmaid stood rigid with her hand on the bar handle in the middle of pulling a pint. The colour visibly drained from the Captain's face to a ghostly white. Suddenly the silence was broken by a Liverpudlian scouser shouting out, 'The dirty lying b_____d! When I catch him I'll hang him by his ears from the top of the mast of the Maury!' With that apt comment, the tension was broken and everyone cheered and laughed.

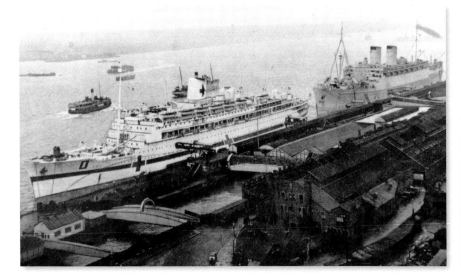

^ In this rare wartime scene HMT *Mauretania* is seen berthed at the north end of the Prince's landing stage, Liverpool. Ahead is the hospital ship *Oranje*. (World Ship Society Merseyside)

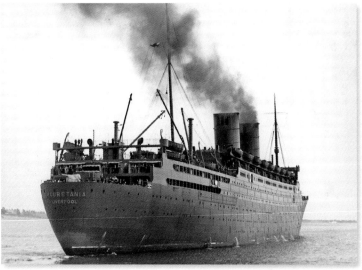

^ The *New York Times* newspaper caption reads, 'An unexpected arrival in New York', and is dated 20 September 1939. Note the gun positioned on the stern of the ship. (Associated Press/Britton Collection)

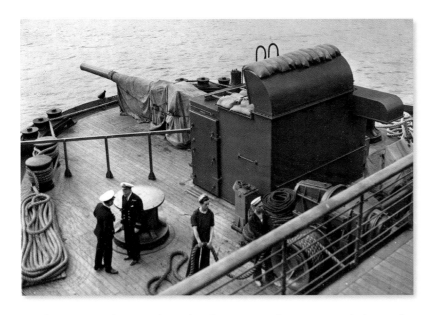

⌃ This unique photograph is dated 20 September 1939 and shows the anti-submarine gun mounted on the stern of HMT *Mauretania* when it docked at New York. (Associated Press/Britton Collection)

As the days dragged on with no firm plans being made there was great concern that the liner would be a prestigious target for the Luftwaffe. The Mersey Docks & Harbour Board requested Cunard White Star to urgently move *Mauretania* to a safer location on 2 November. The Admiralty were slow to respond, but on 30 November permission was granted to transfer *Mauretania* to New York. Preparations were secretly made to steam the ship and she sailed unannounced from Liverpool on 10 December 1939. However, *Mauretania* had been spotted from the air by a lone German reconnaissance aircraft. Believing that the Nazi plane had signalled ahead to a waiting U-boat pack, the captain of *Mauretania* ordered maximum full speed ahead at 26 knots following a zigzag course to avoid incoming torpedoes. Lookouts gazed through binoculars from every vantage point around the decks of the liner, but the speed of the ship saved the day. She arrived safely in New York and docked at Pier 90 on 16 December, to be berthed alongside the pride of the French Line, *Normandie*, and the Cunard *Queen Mary*. This magnificent trio were joined by the Cunard *Queen Elizabeth* on 7 March 1940, making her maiden voyage, a top-secret dash across the Atlantic. The *Mauretania* was hastily moved to

Pier 86 by Moran tugs on the afternoon of 6 March 1940 to make way for the inbound *Queen Elizabeth*.

On 6 March 1940, the *Mauretania* was officially requisitioned by the Ministry of Shipping under the Liner Requisition Scheme Regulation 53. Cunard immediately supervised the removal of all furnishings from the *Mauretania*, to be placed into store in New York. Public and private staterooms on board were unceremoniously stripped ready to accommodate troops. A skeleton crew were quietly transferred aboard from SS *Antonia* after darkness on 18 March 1940 and the boilers were secretly steamed and the engines turned over. Unannounced and under a veil of secrecy the *Mauretania* slipped her moorings at 8 p.m. on 20 March 1940. Her destination was top secret, but she steamed at full speed to Australia, with stops in Bermuda, Colón (passing through the Panama Canal on 27 March), Balboa and Honolulu prior to arriving at Sydney on 14 April. Here work immediately commenced at Cockatoo Island Dockyard on converting the *Maury* into a troopship. She was officially renamed as HMT *Mauretania*.

The modifications to HMT *Mauretania* included:

- The construction of a new gunnery and radar tower.
- The installation on the captain's deck and sports deck of twelve guns, four rocket stands and thirty-six ammunition boxes.
- The fitting of plastic armour around the navigation bridge.
- The construction of a steel bulletproof screen around the wheelhouse and plastic armour bulkhead within.
- The equipping of the engine room casing top and aft funnel casing with two guns, gun pits and ammunition boxes.
- The siting of a gun on the raised promenade deck.
- The installation of a 12lb gun next to the steering engine skylight.
- The positioning of a brace of 12lb guns on the forward main deck with gun pits and ammunition boxes, and two Oerlikon guns protected by an armoured shield.
- The mounting of two Oerlikon guns with gun pits and ammunition boxes on the main deck aft.
- The fitting of two PAC rocket guns, a 12lb gun, a 6in gun and ammunition boxes on the after docking bridge.

In addition to equipping the ship with defensive weapons, she was extensively modified internally with the verandah café and cabin class smoke room being converted into a hospitals and staterooms fitted with Simmons cots, standee berths, hammock berths and toilets. Extra loudspeakers, water fountains and latrines were installed throughout the

ship. Guard rooms and canteens were liberally constructed at various points on the liner. Sadly all the meticulous craftsmanship undertaken at Birkenhead during the fitting out of the *Mauretania* the previous year was now destroyed, within just three weeks. This was compounded by a destructive fire caused by sparks from an acetylene torch, which broke out in No 5 hold on E deck where valuable original Wilton carpets, teak furniture and oak beds were stored. The charred, blackened ashes from these stored Cunard treasures were gathered up and unceremoniously dumped over the side. By early May 1940 HMT *Mauretania* was inspected and declared fit for purpose. She sailed from Sydney to Fremantle with 2,184 Australian troops on 5 May. Briefly halting at Fremantle, she took on a further 162 men and continued on to Cape Town where forty-eight Red Cross nurses came aboard. From here the *Mauretania* joined a convoy setting out to Greenock at a stately 19 knots. She eventually arrived at Liverpool on 22 June where the captain contacted the Ministry of Shipping requesting an urgent meeting to discuss convoys of faster ships at greater speed to avoid submarine attack. The request was initially denied, but the proposal was later implemented on 7 April 1941. On 8 January 1941 she was involved in a minor collision with the American tanker *Hat Creek* in New York Harbor.

The Admiralty officially referred to and coded the large passenger liners as 'monsters'. A number of troop-carrying 'monster convoys' were assembled in the Pacific to transport troops to the fronts in North Africa and the Far East, the largest of which was Convoy US10.

Mauretania sailed from Wellington in New Zealand on 7 April 1941 in Convoy US10, reaching Sydney on Thursday 10 April. *Mauretania* was joined by *Queen Mary*, *Queen Elizabeth*, *Nieuw Amsterdam* and *Île de France*, perhaps the greatest convoy ever assembled, and sailed onwards to Fremantle carrying 22,000 servicemen. The *Mauretania* carried on board 4,400 lively New Zealand troops. The ships were able to maintain a speed of 26 knots sailing together in strict columns of 1,000ft apart, at a separation distance of 800 yards. The convoy followed a set zigzag course and were escorted by one heavy cruiser and a number of lighter cruisers. Such was the importance of this convoy that it was shadowed by the Royal Navy battleship HMS *Howe* and two destroyers. The *Mauretania* left the convoy at Colombo and continued onwards to Port Tewfik to disembark her troops.

MY CRUISE

By G.T. Ropley

Outward trip – sailed from Wellington on 7 April 1941 on HMT *Mauretania*. Cunard White Star Line

Date – Thursday 10th April
Place – Sydney
Arrival – Anchored in stream, no leave
Departure – Friday 11th

Queen Elizabeth, *Queen Mary* & *Île de France* have joined us in the Convoy. We must be a magnificent sight with all three large boats. The Nieuw Amsterdam berthed but no leave was given to the troops.
Are now sailing for Fremantle.

Date – Wednesday 16th April
Place – Fremantle & Perth
Arrival – 16th April
Departure – 18th April

We anchored in the stream on the 18th but had no leave. We finally left on Saturday morning at 0900hrs.

Monday 7th

We moved from the wharf at approx 1200hrs. Big crowd allowed on to see us off. Nieuw Amsterdam left first & it was a great sight. All boats in harbour blew sirens etc. anchored in stream & did boat drill. Six in cabin with sail room attached. Meal in officers dining salon, & are marvellous. At 1600hrs headed for the open seas. Lynch sent me in cheerio message from Fort Dorset. We all had a shock with the price of drinks & cigarettes at the cocktail bar. Retired to bed early feeling sleepy after a good dinner & liqueur. Three escorts me in front & two at side.

Thursday 17th

Still in port & leave to be granted in the afternoon. In the morning we all made a pretence of doing some work but most of us including myself felt pretty awful. Bob Wallin gave a lecture, or should I say, read this out of a book. Arthur could not make the grade for breakfast & he certainly looked a job – he did not arrive back until 4am but as he had been drinking with the T C of the boat everything was alright. We had leave from one o'clock until midnight & I determined to see some of the sight around the town. We all went into town in a bus (incidentally they have women bus conductors) & had lunch at the 'Lattice'. Some of the lads went to the zoo but Bruce, Alan & I went along to Anzac House to get a lift from the officials & be shown over the town. A woman took us all over the place, we visited

Kings Park, a lovely place which covers a few square miles & it overlooks the town. Also the Free University of Perth, which is a marvellous building in beautiful grounds. Parliament House was another place of call but this was very poor. We returned again to Anzac House & then adjourned to the Savoy for a drink (at this Hotel they had six quite attractive young barmaids & were the boys there eyeing them). The place was full of soldiers.

I did some shopping namely photographs etc & then adjourned to the Palace where all the boys were. We stayed until 7.30 & then went to the Lattice for tea. After tea John, Arthur & I adjourned to the Esplanade & had a drink or two – we met a Mr Green & with difficulty got away from him. We adjourned back to the Palace Hotel to meet the other boys but they had all gone off to Rose Street & have a look at the sights. We adjourned to the Government House Ball & had a few dances. I met quite a nice young thing but as the dance finished at 10 o'clock she had to go home. We went around to the Adelphi but it was closed as the police had

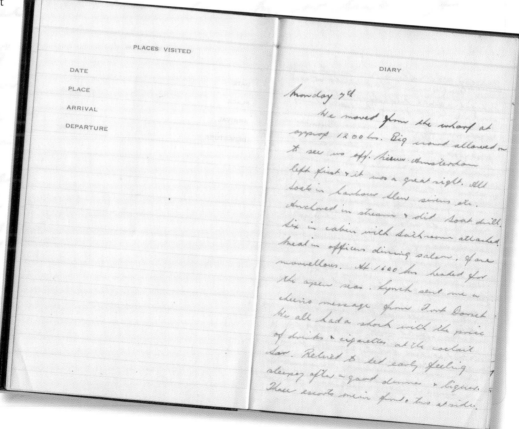

been there. We then went to the Esplanade but when we arrived the police were raiding it so waited until they left, then went in without difficulty. Bruce & I did a little drinking & at a table beside us was an Aussie & a couple of blossoms whom we later discovered were nurses. They weren't bad looking. After a while we were invited to join them which of course we did. At 11.30 the boys had a taxi & we were going back with them but the Aussie said he would drive us back so we stayed on until after one o'clock. By this time the little blond nurse & I were the best of pals so when we went to the car she & I got in the back. Of course did a bit of wooing & I shall say she was nice – of course it would be my luck to meet her on our last nights leave. He drove us back at a terrific pace and at one time touched over 90 m.p.h. When we arrived at the boat we sat in the car & drank some more beer, Cynthia & I had a drink or two & then did a spot of wooing. Bruce wooed the one in front. After 2am we decided we had better get back to the boat so after fond farewells we made our way back. When we got to the gangway the officer of the guard took our pay books which was not too good. Bruce, however, was able to get them back when he saw him later in the evening as we were lucky to get out of a spot of bother – for a time conditions were bad but it cleaned up. We heard nothing more. There were some funny incidents in town:

1. Three chaps hired horses & galloped through the town – they tried to take the horses the bar at the Savoy but couldn't.
2. One chap put on a pair of pink bloomers & wandered around the town.
3. Another lad put on a pair of corsets & with an umbrella wandered around drunkenly.
4. Another lad asked a policeman on point duty would he like a glass of beer. He said no as he was on duty, so a number of lads brought out a table & chairs & a pint of beer, put the policeman in the chair & he directed traffic with one hand & drank the beer with the other.

▲ This diary is an original first-hand account of Convoy US10. (Britton Collection)

There was a very pretty lane called 'Tudor Lane' with old English shops in it & at the entrance there was a big clock with St George & the Dragon. At every quarter hour St George charged the dragon & at every hour St George slew the dragon.

Next the *Mauretania* sailed to Durban in South Africa, which she used as her home port for the next eleven voyages with shuttles to Bombay, Suez, Port Tewfik and Aden. She worked turn and turn about with the *Île de France*, each unescorted and delivering 6,500 troops at a time. Return voyages were swelled with Italian and German POWs, wounded and rotating troops. During the night of 15/16 May 1941 disaster almost struck both liners.

The *Île de France* sailed from Durban on 7 May with 5,000 British and Australian troops bound for Bombay proceeding at a speed of 22 knots following a zigzag course against enemy attack. Heading in the opposite direction at 26 knots was the *Mauretania*, loaded with several thousand POWs and wounded troops. They were scheduled to pass each other some 50 miles apart, both completely blacked out as normal. That night heavy monsoon rain whipped up by strong winds made conditions intolerable. Both liners were rapidly approaching each other in the pitch dark, but there was no reason to assume that the 'monster ships' would pass each other closely.

On the *Île de France* at 3.59 a.m. on 16 May Hubert Rowntree relieved First Officer Geoffrey Wild on the watch. Both officers stood together on the bridge for a few minutes. Then, satisfied that Rowntree had acclimatised his vision to the darkness, First Officer Wild retired to the chart room. Here he began to study the course directions on the charts with Second Officer Trenfield. Almost immediately he heard Rowntree scream out, 'Hard a-starboard! Hard a-starboard!' The first and second officers felt a great shudder as the *Île de France* strained to turn to starboard. They rushed out on to the bridge to hear Rowntree cry out, 'There's a massive ship dead ahead!'

Meanwhile on the *Mauretania*, a report came down from the forward lookout: 'Smoke dead ahead!' First Officer Reg Aylward peered out into the monsoon haze through his binoculars in disbelief. His frenzied voice called out, 'Ship dead ahead on collision course! Hard-a starboard! Hard a-starboard. Now!' On the *Mauretania* it was too late as the ship failed to respond in time.

Within seconds both liners smashed past each other in a wall of white water. Witness statements from both crews state that a man could have reached out and actually touched the other. The written statements from the crew of the *Mauretania* show that the complete ship lifted out of the water momentarily before crashing down to send an alarming vibration throughout the ship. The vessel swayed uncontrollably for some minutes after the near collision, listing violently to starboard and then to port.

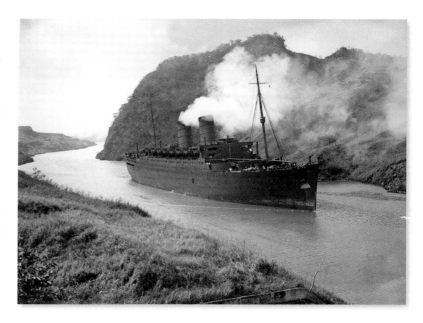

∧∨ Whilst searching through the forgotten files of the *Chicago Tribune* for this book, two hidden, possibly unique, photographs of HMT *Mauretania* were discovered, showing the ship secretly making her way through the Panama Canal on 28 March 1940. The newspaper caption reads: 'The liner left New York last week with reports circulating to the effect that she was bound for Australia where she will be used as a troop ship.' (Associated Press/ Britton Collection)

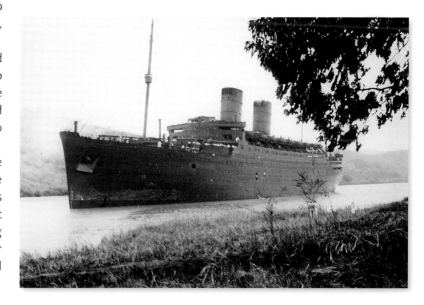

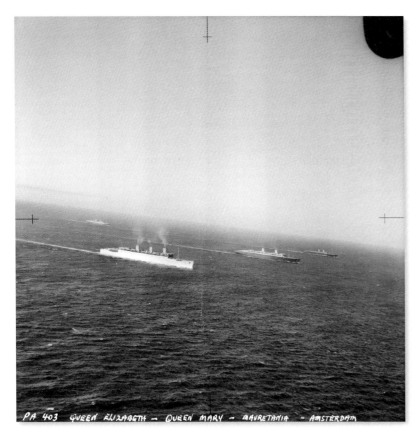

PA 403 QUEEN ELIZABETH ~ QUEEN MARY ~ MAURETANIA ~ AMSTERDAM

❮ A stunning aerial view taken on 11 April 1941 showing the convoy with HMTs *Queen Mary*, *Mauretania* and *Nieuw Amsterdam*. This is the same convoy which is recalled in the war diary on pp. 22–24. (Australian War Memorial)

⌄ HMT *Mauretania* anchored in Sydney Harbour in May 1941. (Australian War Memorial)

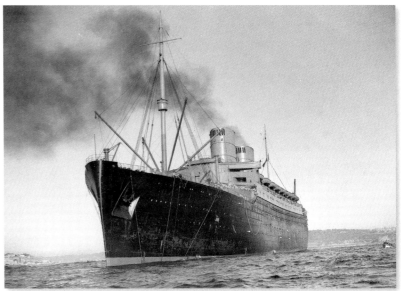

The combined speed of the *Île de France* and *Mauretania* was almost 50 knots. The greatest wartime disaster had narrowly been averted, for if there had occurred a head-on collision of over 80,000 tons of shipping at that speed, very few of the thousands of souls aboard would have survived.

The incident was reported by both crews and a 'D notice' was instantly posted. Following an immediate inquiry by higher authorities all those involved – officers and crew members alike – were brought to Durban for a behind-closed-doors secret meeting. They were severely warned by Vice Admiral Sir Charles Woodhouse never to repeat or mention to others what had taken place that night and this was to remain an Official Secret.

On 28 June 1942 the *Mauretania* sailed from Durban carrying just over 3,000 of Rommel's German Afrika Korps POWs captured in the North African campaign. The destination was Newport News in the USA, via Port Elizabeth, Rio de Janeiro and Bermuda. Whilst anchored in Rio for refuelling, a small group of POWs attempted to escape from the ship. In almost dead silence they broke a sidelight, retrieving the glass intact with treacle. Under the cover of an overhead lifeboat, the resourceful German prisoners slid down a rope blanket and began to swim ashore. Unfortunately for them a patrol boat spotted the exhausted German prisoners and fired a warning salvo over their heads, causing them to surrender immediately and be returned to the ship. They were greeted back on board by whistles and cheers from singing colleagues.

A few months later, on 2 September, Rio was the scene of another momentous occasion in *Mauretania*'s wartime career. A 50,000 Deutschmark bounty had been posted by Adolf Hitler for the sinking by any U-boat captain of the Cunard Queen ships or the *Mauretania*. Following the completion of refuelling with Bunker C fuel oil, the

Mauretania began to raise steam in her boilers ready to sail. At 11.27 a.m. an urgent message was received from the US Navy advising the captain, 'Remain at anchor until further orders'. At 3.15 p.m. British and US naval officers boarded the *Mauretania* to advise the captain that a Brazilian Air Force patrol had observed at 10.30 a.m. a U-boat on the surface lurking just outside the harbour near Itaipu. Furthermore, a small 'wolf pack' was heading south to rendezvous west of Lagoa de Marica with the intention of torpedoing and sinking the *Mauretania*. A brave and bold decision was made to sail out at full speed and break out into the South Atlantic following a south-western narrow but deep-water channel, through the islands opposite the Copacabana and Leblon. Without hesitation the captain set sail and, stealthily manoeuvring the great liner along a pinpoint-accurate course, sprinted past unsuspecting and astonished sunbathers on the Copacabana beach. Her wash caught out many as it charged up the golden sandy beach. Now she was free and headed out into the open Atlantic, building up speed rapidly to over 26 knots. In order to confuse any U-boats she then began to zigzag unpredictably. At last the *Mauretania* was free of the threat of stalking U-boats waiting to pounce.

The wartime marathon 36,454-mile voyage of the *Mauretania* commenced on Christmas Eve 1942 from Wellington in New Zealand bound for Liverpool. The ship called en route at Honolulu, San Francisco, Honolulu again, Wellington, Fremantle, Bombay, Diego Suarez, Cape Town and Freetown. Among the passengers on board were Kiwi pilots destined to fly bombing raids over Germany, and elite Australian troops.

When the North African campaign ended in May 1943, the decision was made to transfer the *Maury* to the North Atlantic ready for the preparations for D-Day and the invasion of mainland Europe. Between 27 August 1943 and 17 March 1945 the *Mauretania* would make twenty

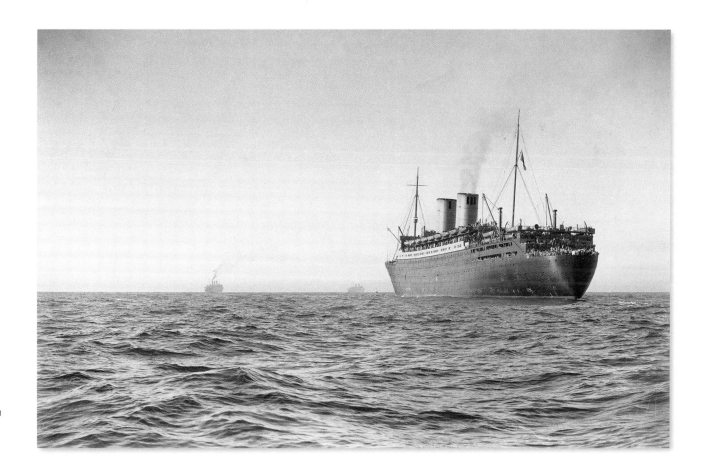

❯ HMT *Mauretania* is pictured moving down in Sydney Harbour after embarkation of Australian troops. (Australian War Memorial)

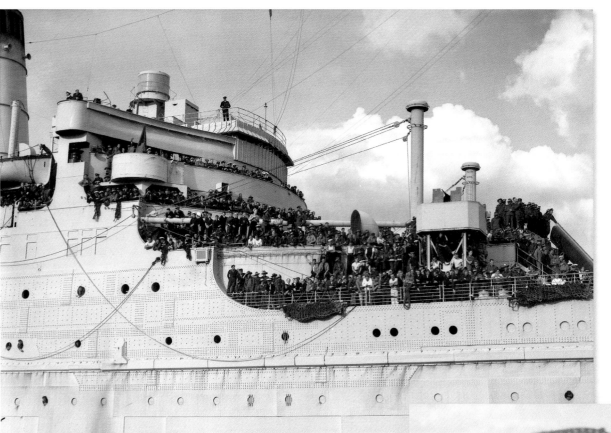

❮ HMT *Mauretania* arrives in Sydney Harbour packed with returning Australian troops who are packing every vantage point on the deck. (Australian War Memorial)

⌄ The smiling faces of Australian soldiers Private A. Malcolm, Private A. Bruce and Private T. Male peer out from the decks of HMT *Mauretania* at loved ones on the quayside on 8 August 1945. (Australian War Memorial)

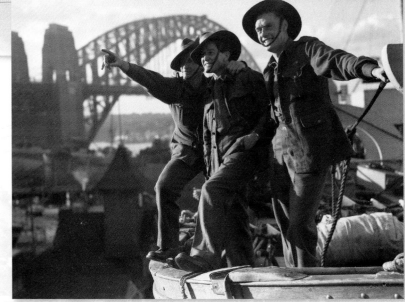

round trips across the Atlantic, carrying 173,991 troops. On 26 June 1943 the *Mauretania* made her final voyage in the eastern theatre of war, returning from Ceylon to Liverpool on her thirty-second troop-carrying voyage. The voyage home to Liverpool took her via Port Tewfik, Diego Suarez, Cape Town and Freetown.

In early 1944 the *Mauretania* was heading east unescorted in the Western Approaches off the north-west coast of Northern Ireland carrying 5,500 American GIs to Britain when an urgent signal came in from Naval Intelligence. The signal informed the captain that two U-boat packs were closing in on her course, one heading south from between Iceland and the Faroe Islands and the second pack heading north approaching from the west coast of Ireland off Galway. With the gap narrowing by the minute the captain of the *Mauretania* demanded every knot of extra speed from the engine room. Somehow the troop-laden ship escaped the jaws of certain death. Yet the *Mauretania* was still not out of danger as ahead a U-boat captain peered through his periscope from below the surface to await his quarry. Feeling confident in the early hours of darkness, the hunter surfaced 5 miles ahead, but was immediately detected by the radar on the *Mauretania*. Sensing the presence of a trap, the captain of the *Mauretania* immediately ordered a complete turn about. The U-boat captain broke radio silence to signal the change of course and position of the *Mauretania* to the approaching wolf packs. This gave the game away, as the signal was picked up by Western Approach Command in Liverpool. The *Mauretania* now set an unpredictable zigzag course at full speed and outflanked the predators, arriving unscathed into Clydeside.

After VE Day and the surrender of German forces, the *Mauretania* was again transferred to troop carrying in the east. She returned thousands of exhausted Australian, New Zealand and Indian troops to their homelands. Following her eighty-one-day epic 28,662-mile voyage around the world, Japan surrendered and the war was over. Although peace had been declared, the *Mauretania* remained in His Majesty's Service continuing to repatriate troops to Australia, New Zealand and Canada. Some of her final government service voyages were to convey GI brides to the USA and Canada. The final government return voyage from Liverpool to Halifax was on 19 August 1946. Field Marshal Montgomery and members of the Warwickshire Regiment were amongst the passengers as the *Mauretania* docked in Liverpool on 2 September 1946. Here she was formally handed over to the builders for refit and restoration.

As a final total, between 1940 and 1945 the *Mauretania* carried 350,178 troops and steamed 542,446 miles.

POST-WAR YEARS

The extensive seven-month refit commenced with the removal of all weapons and wartime armour. When she entered dry dock the hull and superstructure were scrapped and sandblasted to remove rust, wartime matt grey paint and a coating of barnacles. Just over 700 tons of sand ballast were removed and 400 tons of redundant pig iron. The huge crane Mammoth was called upon to temporarily lift out the 72-ton after funnel in order for pre-heaters to be installed. The boilers were completely re-tubed, with new stays added and the replacement of the 15,000 fire bricks. Wooden decks were refurbished and re-caulked.

Furniture, fittings and original artwork that had been placed in store at Salisbury, New York and Sydney were returned to Liverpool. Skilled carpenters from Bath in Somerset and the original suppliers Morris Furniture of Glasgow were sent to refit the luxury cabins and staterooms. The tourist class capacity was reduced by over 100 and the opportunity was taken to extend and improve crew quarters and facilities. By early April 1947, the *Mauretania* was complete for testing and snagging inspection.

On 18 April 1947, with the refit complete, Cunard invited representatives of those who undertook the refit for a two-and-a-half-day cruise from Liverpool to the west coast of Scotland. Heading north from the Isle of Skye, the weather conditions deteriorated rapidly, forcing the renovated liner to return to Liverpool. On 21 April the strong winds prevented the *Mauretania* from sailing safely up the Mersey and she was taken to a 'safe anchorage' at Moelfre Bay. Unfortunately, here she dragged her anchors and was forced to head back out into the Irish Sea to ride out the storm. The invited guests were unable to return to Liverpool until 26 April, a mere two days prior to her first scheduled peacetime sailing to New York. A tremendous round-the-clock effort was made by the local Cunard staff and Liverpool stevedores to prepare the *Mauretania*. She sailed on time and arrived in New York on 2 May. The return voyage was a fast run, averaging 24.3 knots over five days, twelve hours and thirty minutes from the Ambrose lightship to the Liverpool Bar – a personal best for the great ship. Following her next voyage across the Atlantic, the *Mauretania* returned to Southampton, where she teamed up with the newly refitted *Queen Elizabeth* on the Southampton–Cherbourg–New York service, until the refitted *Queen Mary* was restored to operational service.

Once the *Queen Mary* re-entered service, the *Mauretania* changed her scheduled route to Southampton–Le Havre–Cobh–New York until the winter of 1947. The *Mauretania* then restarted her pre-war two-week Caribbean programme of five Sunshine Cruises from New York to Nassau,

Caracas, Curaçao, Colón and Cuba, with two days in Havana. From this date until 1958 the calendar routine was for North Atlantic sailings substituting for the Queen ships during refits, and the aforementioned programme of winter cruises.

By the mid-1950s air travel was beginning to have a noticeable effect on Cunard transatlantic passenger receipts. This downward trend was accelerated by the introduction of Boeing 707 and de Havilland Comet jet aircraft, which attracted greater numbers by the further reduction of travel time. The directors of Cunard realised this and the implications for the *Mauretania* were to be a future more concentrated on cruising. With this in mind, the *Maury* returned to the Gladstone Dock in Liverpool on 3 October 1957 for a £291,666 refit, to include an extension of her air-conditioning system throughout the ship. She set out from Southampton to New York on 17 January 1958 to commence her regular Caribbean cruising programme.

For her annual refit in the late autumn of 1962, the *Mauretania* was sent to the King George V Graving Dock in Southampton. Fern Bussell and his team of painters had instructions to sandblast the paint work and repaint the ship in three shades of Cunard cruising-green livery, similar to the *Caronia*.

The board of Cunard now decided that the *Mauretania* should cruise the Mediterranean with ten voyages from New York to Naples via Gibraltar, Cannes and Genoa. Unfortunately this choice of route proved to be a financial disaster, for the *Maury* was now in direct competition with the modern Italia liners *Christoforo Columbus*, *Leonardo Da Vinci*, *Augustus* and *Giulio Cesare*. The competition was compounded by the American Export Line ships *Constitution* and *Independence*, which almost mirrored the *Mauretania*'s route. The '*Mauretania* Mediterranean experiment', as it became unofficially known, was a complete financial failure. Upon arriving in New York on the eighth of her nine-day voyages from Naples, the two remaining advertised cruises were prematurely cancelled.

Following a refit in Liverpool, the *Mauretania* commenced a cruising itinerary from Southampton in January 1964, with cruises to the North Cape of Norway, the Caribbean and the Mediterranean. She also made a glorious return to the North Atlantic run for a series of eight round trips, the final one starting on 4 August 1964.

A highlight of the career of the *Mauretania* occurred on 27 October 1964 when she was chartered by the Regent Petroleum Company for the opening of the refinery at Milford Haven in Wales. 'The Cunarder' train was provided to take invited guests from London Waterloo station to Southampton Ocean Terminal, suitably hauled by Merchant Navy class Pacific steam locomotive No 35004 *Cunard White Star*. Nine Elms locomotive shed in London provided the elite driver A.E. 'Bert' Hooker to drive the special train. Upon arriving at Ocean Terminal the guests were greeted by Captain John Treasure Jones as they boarded the *Mauretania* for the sea voyage to Milford Haven. She berthed alongside the new jetty and the guests were transferred to a fleet of waiting coaches. The refinery was opened by Her Majesty Queen Elizabeth the Queen Mother, who came on board the *Mauretania* for dinner prior to the return to Southampton and Waterloo.

On 15 September 1965 the *Mauretania* sailed from New York on a sixty-one-day cruise of the Mediterranean and Black Sea. She returned to Southampton on 10 November. During the voyage it was announced that this was to be the ship's final revenue-earning cruise, as on arrival she was to be withdrawn from service. No sooner had the ship tied up, than removal of required recoverable assets began for transfer into storage.

Days later, on 20 November, the *Mauretania* sailed from Southampton on her final voyage to Ward's scrapyard at Inverkeithing, where she arrived three days later to be cut up.

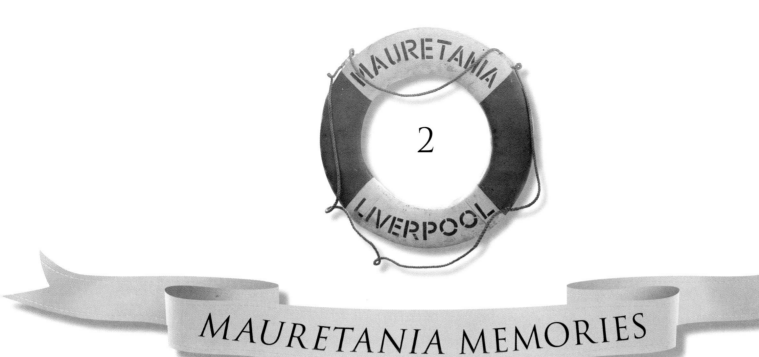

COMMODORE GEOFFREY THRIPPLETON MARR

'They go down to the sea – O me! –
What ships that outbrave the sea,
What ships that outrun the gale,
With a feather of steam for a sail
And a whirling shaft for an oar,
Are the ships that my brothers build
To carry me over the sea,
That my hand with treasures filled
May knock at the morrow's door!'

I have always loved poetry and this verse in particular reminds me of the majestic *Mauretania*. I first glimpsed sight of her in New York when working on the Cunard liner RMS *Queen Mary* as junior third officer just before the Second World War. She gleamed in the morning sunlight, looking resplendent in her new paintwork. During the war I passed her at sea and in port, but at this time the *Mauretania* was in her drab wartime grey livery.

In late November 1945 I returned from an active wartime service in the Royal Navy to my home at Ashurst in the New Forest. At last I was enjoying some long overdue leave, including Christmas with my family. Following formal discharge from the Navy, I wrote to Cunard at Liverpool to inform them that I was available again, but I still had a month of demobilisation leave due. To my surprise by return of post, I received a letter appointing me as junior first officer of the RMS *Mauretania* with instructions to travel up to Liverpool to join her on 14 January 1946.

So much for my demob leave, but it was good to be back with old Cunard friends in familiar surroundings, in peacetime routines. The *Mauretania* was in a very run-down state in her wartime grey, and still under the orders of the Ministry of Shipping. We made an Atlantic crossing to Halifax, Nova Scotia, carrying war brides and their babies and a trooping voyage out to Bombay. On the return voyage on the *Mauretania* we carried the Prime Minister of Nepal and his entourage, and contingents of troops which were to represent the British Empire in the victory parade through London. My lasting memory of this particular

voyage on the *Mauretania* was one of the sound of rehearsing Indian bagpipes and smell of curry as we steamed across the oceans. The Indian Sikh soldiers, with their khaki turbans, were the most hospitable people and I was privileged to join them for a hot Garam Masala curry.

On our next voyage on the *Mauretania* to Bombay I was invited with Captain George Cove to dinner at Government House. We presented ourselves in full dress white uniform. This was my first introduction to oriental splendour and traditions, which were maintained at Government House right up to the end of the British Raj. We were treated to a military band playing a slow march as the Crown Governor Sir John Colville KBE led us stately into dinner. We were very formally announced as the captain and first officer of the *Mauretania*. There was a turbaned Sikh servant standing to attention behind each chair to cater for our every need. After dinner there was the very British tradition of coffee and cigars with a frame of snooker, before returning to the drawing room to rejoin the ladies. This was part of our nation's past which has now gone.

Upon returning to Liverpool, the *Mauretania* was to be laid up for refit to restore her to her former glory. Waiting for me was a letter instructing me to transfer to the *Queen Mary* after a spell of leave at home in the New Forest. The next time I would sail on the *Mauretania* would be as relieving captain between November 1963 and March 1965, covering for my old friend Captain John Treasure Jones.

The *Mauretania* was now working permanently out of Southampton, covering for the Queens when they were undergoing refits, and she undertook winter Sunshine cruises. At this stage of her career the ship was painted in green cruising livery and she was fitted out with air conditioning.

In the winter of 1964, I had to relieve on the *Mauretania* for a Caribbean cruise from New York. The tropical weather in the West Indies was marvellous and the temperatures were very high. The crew wore short-sleeved shirts and white issued uniforms. The end of the cruise came around rapidly and it was time to steam north to New York. When we arrived at the Ambrose lightship we encountered a blizzard which covered the decks with a carpet of snow. Heading through the narrows I received reports from the Moran tugs sent out to bring us in that the Hudson was iced up. As it was now night time and pitch black the ship's lights were on to illuminate the *Mauretania* like a Christmas tree.

When the New Jersey Sandy Hook pilot, Robert Ahrens, had safely boarded and taken control on the bridge, I ventured out into the freezing cold wrapped up in my greatcoat, scarf and gloves. As the ship slowly made her way up the ice-covered Hudson, I could hear the cracking sound of ice. At times there was a screeching sound, like a squealing pig, followed by a crack. As we approached Pier 90 the New York Reynolds Association docking pilot took command and called out the routine orders to our quartermaster: 'Steer three-two-five. Slow ahead. Approaching the pier. Forty feet away. Thirty feet away. Twenty feet. Stop engines.' When we were securely alongside, I ordered a mug of hot Bovril with traditional toddy of Royal Navy rum for all those on the Bridge to warm up the cockles of their heart on this freezing arctic night. The temperatures outside were now well below zero. The lights illuminating the ship advertised our presence to all New York like a shining beacon.

It was now time for the pilots to say their farewells. Robert Ahrens looked at me and said, 'Fine ship Cap. She moves really swell. I hope to be with you when you sail. Shame about your stacks.' With a wave to all on the bridge both pilots departed down the stairs to the pier below. The bridge was silent. Whatever did he mean, 'Shame about your stacks,' referring to the funnels? I immediately made my way outside followed by all those present on the bridge. To our shock and horror, both forward and aft funnels appeared to be peppered with black holes as if attacked by a gigantic clothes moth! The assembled officers and crew followed me for a closer inspection. Scattered at the base of both funnels was a carpet of red confetti and sheets of what looked like 6ft by 4ft red tree bark. Upon closer examination we discovered that it was the red paint that had covered the funnels. I concluded that whilst in the Caribbean the layers of paint applied to the funnels had expanded with the tropical heat. When we returned to New York they had contracted in the icy temperatures. The paint had therefore fallen off and the cracks of what I thought were ice under the bows may well have been the paint splintering off the funnels. The end result of this was that the *Mauretania* was illuminated on public display to the whole of New York, advertising the Cunard Line in a bad light. I therefore decided to have the funnel lights switched off. Next I signalled ahead to Southampton for a team of painters to be ready with their brushes to restore the paint work as soon as we arrived.

In January and February 1965, we sailed on a cruise from Southampton to Las Palmas and then across the Atlantic to Nassau. The passengers lined the decks and marvelled at the sight of flying fish. As we returned from St Thomas to Madeira and headed north to Southampton, the sun was shining and the whole ship was very happy. The *Mauretania*'s crew were laughing and smiling – there was no better place to work.

On returning to port on 21 February 1965, I heard whispers that the new chairman of Cunard, Sir John Brocklebank, had some radical solutions in mind to solve Cunard's financial problems. One whisper was that the *Mauretania* would be sold. This whisper turned out to be true.

CAPTAIN JOHN TREASURE JONES

I first sailed on the *Mauretania* as staff captain from Southampton to New York at Whitsun 1953 and thereafter intermittently until the summer of 1956. At the time she was covering for the Queens during refits or on the Southampton–Le Havre–Cobh–New York run. She was painted in the classic Cunard livery with a black hull, white superstructure and Cunard red-and-black striped funnels. 'What a wonderful ship,' I thought. As the years passed I gained promotion, first as master of the *Media* in 1957, then as master on the *Sylvania* and *Saxonia* in 1959, but I always had my eyes on one day being master of the *Mauretania*.

In early November 1962, I received a letter from Cunard in Liverpool to inform me that I was appointed in command of the *Mauretania* from 4 December 1962. I was so proud to step aboard and to be greeted with a firm handshake by an old friend, Brian Newcomb. This was the start of perhaps the three happiest years of my career. I was honoured to be captain of the *Queen Mary*, but I think that my time on the *Mauretania* was the best. She was a very happy ship with a great crew. I guess that the reason for this was that we spent so much time cruising in warmer climates. The ship had its own cricket team, of which I was an honorary member. The team would play limited over matches during a stopover on cruises. I also got to play a round of golf on some of the best courses in the world, thanks to the *Mauretania*. My tiger would have my set of clubs ready before we docked.

My first year as master on the *Mauretania* was not all full of success. From 28 March we sailed in the Mediterranean from Naples to New York. This was an experiment by Cunard, which turned out to be a financial disaster as we were in direct competition with the Italia Line and American Export Line ships. The passenger numbers were so poor that by 3 October it was decided by the management in Liverpool to pull out. This was a disappointment but the morale of the crew remained high. We returned to cruise the Caribbean to recoup lost pounds for Cunard.

Cruising with the *Mauretania* in the Caribbean at times presented different challenges. Owing to restricted access it was impossible to berth alongside. We therefore had to anchor and land passengers using the ship's launches. On some occasions it could prove difficult to transfer passengers from ship to launch if the tropical winds made it choppy. When we were in the midst of transferring passengers at Nassau on one occasion, a shoal of barracuda began to circle the launch. I was mighty relieved to see everyone safely aboard.

Fresh supplies could be another challenge. On a number of occasions we took aboard fresh local produce, such as bananas, grapes, oranges, mangoes and pineapple. Unfortunately at times inside the boxes of fruit were uninvited guests: spiders and snakes! Luckily this resulted in nothing too serious for the crew other than a swollen wound from a spider's bite. Fresh water supplies could on occasions be a bit of a nightmare. On one cruise it became apparent that we were going to run dry. Neither Kingston nor Veracruz could supply the *Mauretania* whilst the ship was at anchor. However the situation was now becoming a bit desperate so I consulted the harbour master pilot at Kingston and our agent. After much debate we decided to berth alongside one of the wharfs, but we could only get two-thirds of the ship in. I therefore instructed Chief Officer Thomson to spread the anchors to hold the bow in to the berth while we replenished our fresh water tank. The operation proved a success, so much so that I managed to slip ashore with my tiger for a round of golf.

Our next port of call on that voyage was Veracruz in Mexico. We were forced to anchor offshore, surrounded by wonderful coral reefs. The sea was crystal clear and the passengers lined the decks peering down to view the exotic tropical fish swimming around the hull. Many of the passengers transferred to the launches for the 1½-mile trip to the landing stage. It was a very humid day with lots of irritating flies and I was not surprised to receive a hurricane warning in the late afternoon. As I had stopped all shore leave for passengers and crew the previous evening, I was reluctant to repeat this again. I therefore only warned passengers and crew going ashore that bad weather was expected and advised them to remain aboard, but if they did go it was at their own risk. I was therefore amazed to see the launches fill up.

All was well that evening, so I left orders to be called if the wind increased above Force 5, as it would then be prudent to weigh anchor and move clear of the reefs to safely ride out a storm. After writing a letter I retired to my bed. At about 2 a.m. there was a call from the officer of the watch on the bridge to notify me that the wind speed was increasing to above Force 5. By the time I got dressed and arrived on the bridge the wind was up to Force 6. Coming alongside were a boatload of returning passengers and crew, who were being tossed around on the waves. The ship was rising up and down and it looked too dangerous to transfer anyone to the gangway, so I sent an order not to attempt it and return to port to await further instructions. The ship held fast at her anchors so I did not move off.

The next morning I made a check of crew numbers and discovered to my dismay that over half of the crew were ashore. With the seas still

running hard, I was unable to bring the crew aboard until about midday, and then only by using a pilot boat. Eventually by 7 p.m., much to my relief, we had all the crew safely back on board. Meanwhile many of the passengers ashore were treated to a grand tour of the city and a cuisine of 'bistec a la Mexicana' and a few bottles of Casa de Piedra, and returned to the ship happy.

This was not the case with all of the passengers as a group of four demanded to see me to make a complaint. They had been on board the launch that I had instructed to return to shore as it was too dangerous to transfer. They bitterly complained that I had endangered their lives, their clothes were wet and ruined and that I had spoiled their cruise etc. I therefore had to remind the angry passengers that they had been advised not to go ashore and had acted against my advice. Sometimes it was lonely and hard being master of the *Mauretania*, but one thing I never regret is that I always insisted upon safety first.

As we headed home the weather continued to be a problem on that cruise. A strong westerly wind picked up in the Azores and we were unable to let anyone go ashore. The local agent came out on a launch with the mail and we somehow managed to retrieve the bag on a line. As the storm picked up, there was no hope of landing, so we took the ship around the island and headed for home.

On 27 October 1964 the *Mauretania* was chartered by the Regent Petroleum Company for the opening of the refinery at Milford Haven in Wales. This was a very special occasion for me as I originated from Haverfordwest in Pembrokeshire, Wales. I would have the opportunity to take my beloved *Mauretania* home where family and old friends could see the largest passenger ship ever to enter the harbour. As a boy, I had left home to work an old tramp steamer, but I never dreamt that I would one day return home as master of an ocean liner.

Cunard informed me that a train of invited guests was coming down from Waterloo on the 'Cunarder' to Ocean Terminal, Southampton. I was instructed to receive the guests and welcome them aboard with Sir Edward and Lady Beetham before taking them from Southampton to Milford Haven and returning them later in the day. The head office of Cunard sent special written instructions prior to this occasion that the ship was to be painted, cleaned and polished to the highest standards and traditions of the Cunard Line. I was also telephoned by the chairman and left in no doubt of these instructions. Painters and the crew set to work with paint brushes and Brasso polish, so that when the big day arrived the *Mauretania* would look magnificent. My uniform was cleaned and pressed, and my best dress shoes were polished and bulled up to perfection – Royal Navy fashion.

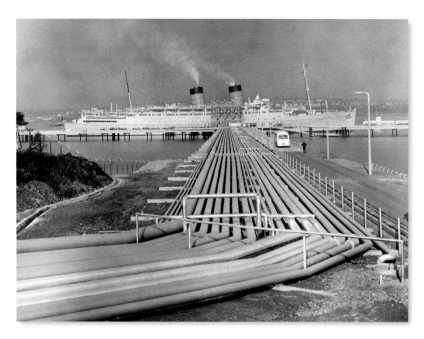

↑ The *Mauretania* is pictured at the new Regent Refinery at Milford Haven, Pembrokeshire, on 27 October 1964. She took invited guests from Southampton to Milford Haven for the opening of the new refinery by Her Majesty Queen Elizabeth the Queen Mother. (Valero Energy/Texaco)

The new Regent Refinery was to be opened by Her Majesty Queen Elizabeth The Queen Mother. After opening the refinery, Her Majesty and all the guests were to come aboard the *Mauretania* for dinner. I had previously had the privilege of being presented to Her Majesty and King George VI when they came aboard the *Queen Elizabeth* in June 1948. Her Majesty was escorted aboard the *Mauretania* by the Cunard chairman, Sir John Brocklebank, who presented me to her. From this point on Her Majesty was escorted by me. My ship's senior officers were lined up and I presented them to Her Majesty. I then escorted Her Majesty to her suite of rooms to be attended by her ladies-in-waiting.

When Her Majesty emerged from her suite, I escorted her to meet a selected number of invited guests to be presented in the smoke room. As we walked along the corridor, Her Majesty set me at ease by chatting about the ship and the local area, for she had been well briefed that I originated from Pembrokeshire. Her Majesty then paused and turned to ask, 'What do you think I have been doing Captain?' I smiled politely

and discreetly replied, 'I have no idea ma'am'. Her Majesty said, 'I have been writing to Prince Charles on *Mauretania* paper. He would love me to do so on *Mauretania* paper.' Before entering the dining room we paused and the toastmaster announced, 'Be standing for Her Majesty Queen Elizabeth The Queen Mother and Captain Treasure Jones.' The room fell silent and as we entered the guests bowed and curtsied as I escorted Her Majesty to her seat and handed her over to Sir Edward Beetham. I then took my place a few seats away.

After dinner I escorted Her Majesty from the Dining Room to the gangplank. 'What a delightful ship you have Captain. The rooms on the Mauretania are magnificent,' Her Majesty said. I shook her hand and said goodbye. What a great honour this occasion had been for the *Mauretania* and me.

In early 1965, with the rapid decline in passenger receipts across the Atlantic, Cunard took the decision to withdraw the *Mauretania* from service at the end of the year and place her up for tender. We had all assumed that she would be purchased by a Greek shipping line and would continue sailing under another flag. Her final voyage was to be a cruise of the Mediterranean from New York, going up the Dardanelles to Istanbul, visiting the Greek Islands and stopping off at thirty-two ports. This was a long but outstanding cruise. During the cruise unbelievable and shocking news was related to me from the Cunard Head Office. The *Mauretania* had been sold by tender to T.W. Ward of Inverkeithing, Scotland for scrapping! I announced this to the crew and passengers who heard the news in silence and disbelief.

Upon arriving back at Southampton at 8 a.m. on 10 October, I was mobbed by the press, radio and television. I could not escape for another 8 hours. Normally I would be off the ship and away home in less than 2 hours. During the afternoon the vultures arrived on board to begin picking and removing valuable paintings, fittings and fixtures to be placed into store. It was sickening how quickly things started to happen. At times like this you need your family and I could not wait to see my wife Belle.

I returned to the ship on 18 November with my wife who was signed on as a member of the crew with a peppercorn wage of one penny per day. Many dear friends who had been members of the crew had been paid off and just a skeleton crew remained on board. Meanwhile the vultures continued to remove bottles of wine, plates, cutlery, furniture etc from the ship. What remained on board were just the bare essentials to get us to Inverkeithing. We set sail for the last time from Southampton on the 20th November. Once again the press, radio and television turned out in force to see us off. However, the docks and shoreline were packed with thousands of well-wishers to say their farewells. It was as if the whole city of Southampton was present. On the other side of the water, Hythe Pier was packed and the shoreline had a line of spectators all the way down to Calshot. A small armada followed us and more joined off Cowes and Ryde. Looking through my binoculars, I could see that Ryde Pier was jam-packed too.

The funeral voyage, as I called it, took us up through the Dover Straits, which is a very busy and hazardous place to navigate at the best of times. The wind started to pick up at this point and we encountered some heavy swells. As we headed up the North Sea the weather continued to deteriorate. Cunard did not encourage wives to travel aboard and I recall that on a previous occasion when my wife had joined me that we had encountered rough seas when heading north up the Irish Sea. Perhaps she was a Jonah as described in the Bible?

The channel leading up to our final destination was quite shallow. We therefore needed to pump out our tanks to reduce the draught down to a maximum of 26ft. Shortly before we entered the channel, the chief officer and engineering officer reported that there was a leak in the pipe

❯ A rather depressed-looking Captain John Treasure Jones, the last Master of the *Mauretania*, stands on the bridge. He rings up on the engine telegraph, 'Finished with engines' at Ocean Dock in Southampton. This was the last time he would bring the *Maury* into Southampton following her final Mediterranean cruise. (Associated Press/ Britton Collection)

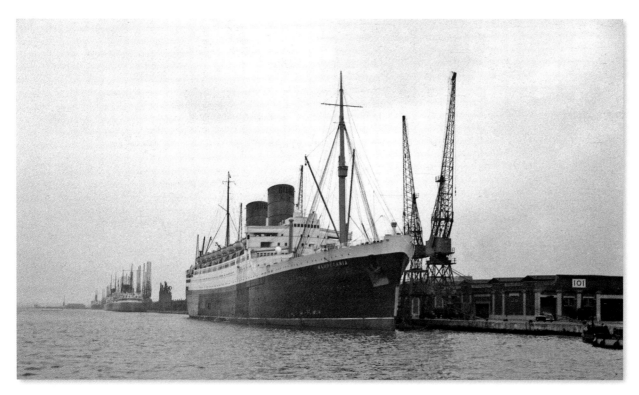

❮ This view must have been taken in very early October 1962 (possibly mid-afternoon of the 2nd) with the *Mauretania* berthed at Berth 101, Southampton. She is awaiting transfer to the King George V Graving Dock, where following her annual refit she will be repainted in Cunard cruising-green livery. This could well be the final picture taken of the *Mauretania* in classic Cunard livery. (Fricker Collection)

work from the tanks, resulting in a draught of 28½ft. Instructions were therefore given to wrap and bandage the pipes to empty the tanks. I was very conscious of the fact that this would be the highest tide of the month. I had no intention of sitting around for the next four weeks, so I made up my mind to enter at 1 a.m., come what may.

I consulted the ship's broker as to the terms of delivery and he informed me that it was Cunard's obligation to deliver the *Mauretania* into the berth in order to complete the contract of sale. If she got stuck when trying to attempt delivery, I would alone be responsible. The pilot reassured me that there was at least a good foot of soft mud on the bed of the channel, and that the ship would be able to push her way through. At this point the managing director of Ward's scrap merchants threw a fit! 'Are you seriously going to attempt bringing her in here in the dark? Don't you know that this is the biggest ship we have had in here? You must be mad!' I replied that if the tugs were willing to have a go, I would attempt to get the draught down further and bring her in following the marker lights. With my mind made up, I decided to retire for a brief rest to clear my head.

Two hours had passed and the draught had been reduced to 26½ft. Two tugs were placed at each end of the ship. This would provide greater flexibility as the ship would steer better using her own engines and propeller. She was lined up in position like at the start of an Olympic race. After sounding three whistles, the forward tugs began to belch out clouds of thick smoke, so much so that we temporarily lost sight of the light navigation markers to guide us in. As we passed over the first shallow patch, the ship started to sheer, but this was corrected by steering with the helm engines. Next a second mud bank shallow, and the ship slowed up. I ordered, 'Full ahead on both engines.' Now the *Mauretania* rapidly increased speed with the end of the dock approaching. 'Full astern on both engines,' was my next order. With 200ft to spare and 20ft off the berth, I gave my final command, 'All stop. Finished with engines.'

The tugs now pushed the great ship into berth. The chief engineer telephoned through frantically, 'The condensers are full of mud. We can't use the engines.' I reassured him that there was no need to worry as the job was done.

I was exhausted and decided to retire with a stiff double Scotch. No sooner had I drifted off to sleep, I was woken up by the chief engineer to inform me that there was a bad leak in the generator room and the ship was taking in water through a fractured pipe. I instructed him to close the watertight doors and not to worry as the generator was no longer required. The next morning when I opened my eyes the *Mauretania* was high and dry with less than 2ft of water in the dock. I gazed back to see where we had entered and could hardly believe it. After taking a last look around my beloved *Mauretania*, saying my farewells to my shipmates and gathering my belongings, I set off down the gangplank. Alongside, hungry scrap men assembled with their gas torches and cranes. My wife and I walked around her through the mud and over debris of twisted scrap metal, not uttering a single word. As I left her behind, I could not bear to look back for fear of being turned into a pillar of salt like Lot's wife in the Bible. I had delivered a dear friend like a Judas goat leading sheep to slaughter. Never again did I ever wish to take a ship to such a place.

ENGINEER OFFICER TERRY GLEED

(Article first published in *Shieldhall Matters* membership magazine. Courtesy of the SS *Shieldhall* Society, Southampton.)

In August 1960, after completing my five-year apprenticeship at J.I. Thorneycroft I joined Cunard and was posted to the RMS *Mauretania* as the lowest junior engineer it was possible to be. I will never forget the first time I ventured into the engine room and on seeing the gauge board on the platform wondered how on earth I was going to get to know how all this worked.

I served on board for a year before being transferred to the *Queen Mary* where I stayed for two years. Obviously by this time the workings became a little clearer and in November 1963 I managed to obtain my 'second's ticket'. I was then reassigned to the *Mauretania* as third engineer and am pleased to say that for the next eighteen months I enjoyed most of my time at sea.

One of the duties of the third engineer, whilst in port, was to be engineer in charge overnight, but not actually keeping watch. I was one of a group playing cards at about 9 p.m. when we saw the lights flicker! Being my first night in charge I was a little nervous and proceeded below to see if there was a problem. With only one boiler being used to provide power for two generators and finding no visible water level you can imagine my horror. I was informed that, 'the water had disappeared a few minutes ago, but the feed pump had been restarted.' I waited a few more minutes but in the meantime shut down one generator. Still no water appeared and I took the decision to shut down completely rather than risk possible damage to the boiler.

The emergency generator was started, but could only provide power for emergency lights and could not be used to pump water into the boiler. I was on my own, my proud second's ticket of no use and, I felt, in distinct jeopardy. I had certainly never experienced a situation like this and was at something of a loss to know what to do for a short while. I knew that the second and chief were ashore and had no other contact available to me. It is now difficult to imagine but the only way to get water back into the boiler was to bring an air line from ashore and attach it to the Weir reciprocating pump and virtually start from scratch. All this took time and certainly made the heart work overtime. It all worked out eventually but for a couple of hours I did not feel at all as clever as I once thought and was distinctly brought down to earth.

The next day, when I had to submit a report the chief engineer, Stan Stockholm, he read it, smiled and said in his broad Liverpudlian accent, 'Laddie, you will never forget last night,' and believe me, I never have.

A few weeks later, in Southampton, we were taking bunkers alongside at Berth 46. I took over from another engineer with only four tanks left to fill. The tank gauges on the *Mauretania* were of the mercury-filled pneumercator type, with each one reading both port and starboard tanks, obviously depending on which way the handle was pointing. All valves were manually operated. Tanks 15 and 16 were different to the remainder in that one put the pneumercator handle to starboard to read the port tank and vice versa for the starboard tank. Quite how this had been left like this since 1939 is beyond belief, but it was so.

The engineer going off duty had left tank 14 filling with 15, 16, 17 and 18 to go. The last two tanks, 17 and 18, were the overflow tanks. I completed the filling of 14 and changed over to 15. This subsequently filled and I changed over to 16 and moved the pneumercator gauge handle accordingly – or did I?

The fact was that as I was unaware of the discrepancy with the tank handles, after the changeover it appeared that the tank I had opened was no longer filling. I strolled up to C deck only to find that the barge was

pumping at full speed. I ran back down below but was still unaware of the situation with 15 and 16. I could not determine what was happening. I then sprinted back up top and told the barge to stop pumping. Unfortunately I was too late. The oil had been going into the overflow tank and when full it overflowed into the dock.

Oh dear, here we go again! Yet another report to say nothing of emergency arrangements to get the dock cleaned. In a way it was fortunate that the overflow went between the ship's side and the dock wall. We were able to mainly contain it and prevent it contaminating the entire dock area.

After all was completed I went home late that night only to receive a telephone call from my father concerning an item on Southern Television news that evening and enquiring if I knew anything about it? Apparently as the overflow went into the dock there was a TV cameraman adjacent to the bow of the ship. He filmed the oil being pumped from the barge into the ship and the overflow the other side into the dock. The quip on the news was that they 'assumed that the ship was full up.' This I was never allowed to forget, adding to the memories, good and bad, of having served on the *Mauretania*.

During the last year or so much of the pipe work was rotting and rather than carry out 'proper' repairs we were told to build cement boxes around the leaks. I cannot recall just how many there were but they must have had an influence on the stability of the ship.

When we returned to Southampton from the final Mediterranean voyage in November 1965, anything wanted by the company was removed from the ship and this included almost all of the tools from the engineer's store. I confess to siphoning off a complete set of open-ended spanners, which I felt would be a lasting keepsake for me – however it was not to be.

We set sail for Inverkeithing and were given the estimated time of arrival by which time we had to ensure that our tanks were to the point at which we could reduce the draught to enable the ship to get over the bar into dock. Soon after we started emptying the ballast tanks the pump failed catastrophically. We were unable to utilise another pump and could not repair the damaged one as there were no tools (other than my spanners) on board to dismantle it and perhaps there were no spares either. We were unable to achieve the required draught.

The skipper, Captain Treasure Jones, decided to go in at some speed and hopefully 'bounce over the bar'. He said that he would give a double ring as we approached the bar. In preparation we put on three of the four generators hoping that all of them would not be lost on the way. In due course we went in. The first we knew of the bar was the double ring on the telegraph and the second was the increasing rumbling and vibration as we hit the bar. Almost immediately one generator was lost and not much later the second one also went. At this time the engineer in the generator room reported that water was flooding into that space through the sewage pump compartment on the port side. He had managed to shut the door but clearly the ship was badly damaged. We then received a call to say that there was water flooding into D deck towards the stern.

By now we had passed over the bar and the remaining generator had stabilised. We proceeded alongside with water becoming apparent in many places where it should not have been. When the order was telegraphed from the bridge, 'Finished with engines', the ship was shut down in double quick time, lest we should find ourselves in even more trouble.

Clearly the *Mauretania* did not want to be 'paid off' and made her feelings known in no uncertain terms. I eventually left the engine room for the last time with just three of the spanners (still in my toolbox today) which I had liberated, and proceeded to exit the engine room. At the top of the companionway I could not believe my luck when I saw the brass engine builder's plate placed there when the ship was built in 1938. I could not leave the plaque for the scrap man and felt it would be a very much better memento than a set of spanners. It therefore found itself in my bag PDQ. There were only two items on the ship which bore the name *Mauretania*. One was the foredeck bell and the other the engine room bell. Both disappeared soon after leaving Southampton for the last cruise – quite where they went is anyone's guess.

OFFICER BERT JACKSON

The allure of the sea is too strong for some and compared with the magnetism of the *Mauretania* life ashore will always be pretty dull. The *Maury* not only offered adventure but she was without doubt the happiest ship I ever worked upon. It was always a great pleasure to go 'Sunshine Cruising' on her to the Caribbean. When we arrived to embark passengers at New York, the routine was that four of her lifeboats would be taken off to make way for special motor cruise launches. They were used for landing our passengers at ports in the West Indies where we

had to anchor off. At times transferring elderly passengers was a bit of a problem, but as far as I recall we never lost one.

Each time we returned to Pier 90 at New York at the end of a cruise, there would be a group of smartly dressed lawyers circling to await our arrival. They were an underhand lot waiting to take up any claims from passengers, with a 50-50 win distribution on successful claims against Cunard, on a no-win, no-fee basis. On one occasion one of these smart-mouthed vultures was perusing an alleged claim for a lady with a broken ankle, which she said had occurred on the *Mauretania* during her Caribbean cruise. Fortunately one of our officers a South African called 'Zulu' Thompson recalled the lady coming aboard with the broken ankle. The ship's photographer had also snapped her hobbling up the gangplank with her leg in plaster. The blow up of the negative revealed the truth and there was no case to answer.

Heading home across the Atlantic on the *Maury* in the depths of winter after a Sunshine Cruise was not something to look forward to. On one such occasion in the early 1950s, the order came to close all watertight doors, lock all portholes, shut all doors securely, shutter the observation windows and prepare for a heavy storm ahead. I was up on the bridge, which was sealed, and the ship headed into the storm with huge grey waves with white tips. Only the reinforced glass observation windows were between those on the bridge and the blinding hurricane. The bow of the *Mauretania* began to dip violently, with waves crashing over the locked forward holds. The normal action of the ship was to pitch down into the trough and then ride up over the enormous wall of a wave. However on this occasion, the ship pitched down over one wave like the side of a steep mountain. Instead of climbing out we hit a 'hole in the sea' with a second trough. Alarmingly the whole ship was now heading down at a severe angle and we were seemingly slipping down under the waves to the bottom of the ocean! Water was now outside the bridge windows and we were sinking fast. 'God this is it!' someone screamed on the bridge. At this point the whole ship must have been completely under water. Then somehow, inexplicably, the ship bobbed up to the surface again like a cork. The air contained within the sealed *Mauretania* had kept her buoyant and saved the day. Captain Sorrell said, 'Yes, thank God indeed.' We were all so glad to step ashore at Ocean Dock in Southampton. Unfortunately several thousand pounds worth of damage had been done to the ship with broken furniture and damaged fittings. Those on board will remember, but few will believe what happened that dark day. [The date of this incident was recorded as November 1952. It is also mentioned as a North Atlantic hurricane in the records of Captain Donald Sorrell.]

We had many famous film stars come aboard the *Mauretania*. Some took a shine to members of the crew which was strictly forbidden. An old friend, Bob Arnott, recalled having to fend off Hollywood screen goddess Joan Crawford on a Caribbean cruise in the fifties and when he showed his wife a signed picture she was none too happy! His wife Joan need not have worried, for Bob was one of the best and most home-loving chaps aboard, totally devoted to his wife and young daughters. Now, Elizabeth Taylor was also one to watch with her fluttering eyes at young stewards and officers, but she had an expensive taste for diamonds, so there was no one aboard the *Mauretania* who could have afforded her, even if it had been permitted!

BERNARD WEBB, BELL BOY ON THE *MAURETANIA* 1947–48 AND FIRST CLASS STEWARD 1955–63

When I left school at the age of 14, my mother took me down from our home in Northam, Southampton to the Cunard office in Canute Road where I was taken on as a bell boy. At first I went up to the National Seaman's Training School at Gravesend from the end of March until mid-May 1947. My first Atlantic crossing was on the *Queen Mary*, where I quickly learned the Cunard traditions and duties. I was given a smart uniform, hat and gloves and my shoes had to be polished daily to a mirror finish. The job required me to run messages, deliver telegrams and flowers, and always with a courteous smile.

On returning home to Southampton, on 5 June 1947, I assumed that I was in for a spot of leave. However, within two days I was sailing again, but this time on the *Mauretania*. The ship had been refitted at Liverpool and had completed her first transatlantic round trip from Liverpool to New York, but she returned to Southampton. Here Cunard planned that she was to work as a running mate with the *Queen Elizabeth* while the *Queen Mary* underwent her post war refit. She came in to Southampton crewed by Scousers, who assumed that the *Maury* was their exclusive ship to be crewed by Liverpudlians only. They were not impressed when Cunard directed crew members from Southampton onto the *Mauretania* – me included!

She was just like a new ship on board and the paint shone brightly with plush carpets, furniture and fittings. I was the youngest member of the

crew at the age of 14 and with my blonde hair I guess that I appeared to be very innocent. The American passengers were so kind to me and the voyage was outstanding as everyone seemed really happy. On returning to Southampton on 27 June, the ship's butcher, who I had befriended, presented me with the leftover prime cuts of meat. He explained that as the *Mauretania* lacked a deep freezer these prize joints and chickens would have to be disposed of and I could therefore have them. The meat was transferred to a waiting taxi and I climbed inside to head home to see my family. We were halted at the dock gate by the dock police constable. He examined the contents of the taxi and would normally have expected a half crown or a Customs charge. Being only 14 years of age, I smiled and looked innocent and said, 'It's my first time on the Mauretania, Constable.' The bemused copper stared back and said, 'Go on, son. On your way home then.'

On the next voyage on the *Mauretania* to New York I bought up several large packs of sugar in New York, which were still on ration in England. Having got away with it once, I decided upon arrival at Southampton to play the young innocent again and it worked. This supply of sugar was distributed by mother to the family and neighbours in Northam. Soon the dates of my return home were eagerly awaited.

After an all-too-short overnight stay at home I returned to the *Mauretania* for another Atlantic crossing. I wish I could have stayed at home as I missed my family. The Hollywood film star Victor Mature must have noticed this and took pity on me, for upon arriving at New York I was sent for. The smiling film star said, 'I have something to cheer you up with in this box.' He gave me a heavy box which I eagerly opened. Inside was a pile of American comics: Batman, Superman and Spiderman. They were a highly prized treasure and like gold dust back home in England. 'They're all yours,' said Victor Mature. After returning to Southampton, I was the most popular boy in our neighbourhood. My next two trips were on the *Queen Elizabeth* and I returned home on 15 December 1947 for Christmas with my family, or so I thought.

I received an urgent message to catch a train to Liverpool for transfer to the SS *Ascania*, a real old rust bucket, for the voyage over to Halifax. On arrival at Halifax in Canada, I caught an express train to New York where I was to join the *Mauretania* on 20 December. I was to be a bell boy on the *Mauretania* for her first post war Sunshine Cruise. She was to assume her pre-war two-week Caribbean 'Sunshine Cruise' programme: five cruises from New York to Nassau, Caracas, Curaçao, Colón and Cuba, which included a two-day stopover in Havana. Although I was really saddened to leave my family for Christmas, I was on a new adventure.

The crew of the *Mauretania* promised me a real treat when we arrived in Havana in Cuba with music, dancing and merriment. They told me that Havana was the seaman's paradise. Great, I thought. At the tender age of 14, I thought I would be presented with lots of new exciting toys or comics. When we landed ashore, I was given a huge Cuban cigar, my

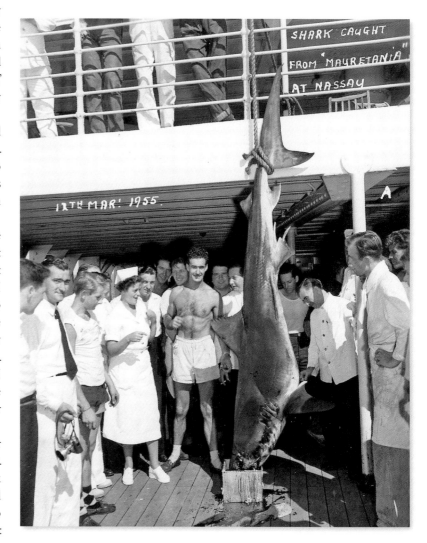

⌃ A shark is proudly displayed on the deck of the *Mauretania*, having been caught from the ship at Nassau on 12 March 1955 by cabin class saloon steward Eddie Roger, pictured in his shorts. (Britton Collection)

first ever. Next my crewmates said we'll take you to the cinema for a film. I expected to see Donald Duck or Mickey Mouse; instead I when the lights went down I could not believe my innocent eyes – it was a blue movie! The *Mauretania* crew laughed and laughed. Havana was a real education in growing up. On returning home to Southampton at the end of March, my father, who worked in the docks, came down to meet me and walked straight past me as he did not recognise me. I had physically grown and was suntanned after enjoying the luxury of Caribbean cruising aboard the *Mauretania*. After a night at home, the next day I was off to sea again on the *Queen Mary*. Two further trips followed as a bell boy on the *Mauretania*, before I transferred away on to other ships to climb the promotion ladder.

I was not to return to the *Maury* until the mid-1950s as a first class steward, where I teamed up with my friends John Owens and John Prescott (now Lord Prescott, the former Deputy Prime Minister). John Prescott worked with me as a tourist class steward. He was a hard worker and keen to study. John always had the welfare of his fellow workers close to his heart and it was not long before he became the *Mauretania* union representative. Cunard soon labelled him as an agitator and did not want him on the *Mauretania* or any of their ships. This humble man with a great sense of humour was to rise to become Deputy Prime Minister of our country and is now a member of the House of Lords. He never forgot his old mates on the *Mauretania*, and to this day we are proud of him.

From the mid-1950s until the *Mauretania* transferred to the New York–Naples service in 1963 were to be some of the happiest times in my life. She was a truly happy ship and the crew all worked together as a great team, from top to bottom. On the North Atlantic run the crew were required to wear formal dark uniforms and waistcoats, but when the *Maury* sailed south on cruises to the tropics, we would change into cooler white jackets.

Shark fishing was always popular with the crew on Caribbean winter cruises. On one occasion a restaurant steward had a bite on his line and fought hard to land a shark. Progress reports were relayed around the *Mauretania*, but when the time came to report on duty the Restaurant Manager Cyril Waring excused the steward all duties until the shark was landed. At last the hammerhead shark appeared to concede defeat and was being wound in up the side of the ship. The passengers and crew began to cheer and clap, when suddenly the line snapped! That poor exhausted steward was back on duty within minutes.

Perhaps the most memorable Caribbean cruise on the *Mauretania* was the Christmas cruise of 1958 to Havana. It was New Year's Eve and the ship was anchored offshore at Havana. Half the crew were celebrating in the city with wine, women and song. The sound of gunfire could be heard from nearby Santa Clara and news came through that Che Guevara had taken the city. Panic began to set in as Fidel Castro's revolutionaries began to move on Havana itself to depose the regime of Cuban dictator Fulgencio Batista. The orders came through: 'Everyone back to the ship immediately.' The *Mauretania*'s tenders were packed as every passenger and crew member fled the city, which was by now descending into a war zone. Steam was hastily raised and a head count was made of all aboard. She set sail at full speed away from Cuba, never to return again.

JOHN OWENS, PLATE CLEANER, TOURIST RESTAURANT STEWARD, CABIN CLASS STEWARD AND FIRST CLASS STEWARD

I joined the *Mauretania* on 6 May 1959 working in the plate cleaning room and worked my way up through promotions to first class steward until she transferred to the New York–Naples service at the end of 1962. The routine on the *Mauretania* was to operate the transatlantic service during the summer and go cruising during the winter.

My first trip into New York was exciting and I was looking forward to going ashore in the USA. After sailing from Southampton, the *Mauretania* anchored at Cobh in Ireland. I was asked to help out on the tender boat with the transfer of fresh supplies. On the return to the ship we were loaded with churns of fresh milk, cream, butter, cheese and eggs. My job was to make sure that they were all secure and this proved to be a bit of a challenge as the tender bobbed up and down on the waves. Only a bit of milk was lost and I don't recall any eggs being cracked. After setting sail we were soon at full speed heading west across the Atlantic, with nothing else ahead but miles of clear blue ocean. I could not wait to arrive in New York and the excitement mounted as we headed through the narrows. Arrival at Pier 90 was a bit of a shock as I was told to hump ashore ten heavy bales of dirty linen off the ship, before they would release me for shore leave.

It was hard work as a steward on the *Mauretania*. Generally we worked in pairs and my regular mate was Bernie Webb. The daily routine was to be up and dressed ready for work at 6 o'clock, have a quick cup of tea then immediately do the bar stock replenishments. When this duty was completed we next had to scrub our allocated lino decking area using kneeling pads, before laying up our station with clean cutlery and serviettes. Breakfast for the passengers was from 8 a.m. until 10 a.m. and we were expected to be ready and waiting dressed in a tuxedo with bow tie and polished shoes. The tables would then be cleared and cleaned, followed by silver polishing outside if the weather was fine. Next, preparations were made for lunch, to be completed by 12.30 p.m., ready for passengers to eat between 1 p.m. and 2 p.m. At the end of lunch the tables would be meticulously cleaned and prepared for the next meal. When on Caribbean cruises, there would be an additional deck buffet at 4 p.m. which we took turns at. After a short break, we would return to duty and prepare the restaurant by 6.30 p.m., ready for the evening dinner between 7 p.m. and 10 p.m. After dinner the restaurant would be prepared again for breakfast the following day. All this hard work on the *Mauretania* was for the princely some of £27 10s per month! We would send £5 per week home to our wives and try to save the rest and any tips.

The crew facilities on the *Mauretania* were very poor with eight sleeping bunks to a cabin. Though this was not quite as bad as the *Queen Mary*, where we had twelve to a cabin! Can you imagine coming off shift in the early hours to scramble around for your locker amidst half a dozen snoring men? Eating facilities were very basic for the crew on the *Maury*, with cramped conditions and sitting on an upturned barrel around a table. One man had compassion and set out to improve conditions for the crew on the *Mauretania* and that man was none other than John Prescott. The improvements that followed, and which we now take for granted on all ships, are down to the now Lord Prescott. To him may I record a big thank you on behalf of all seamen.

The most popular place on the *Mauretania* for the crew was the Pig & Whistle crew bar at the aft end of the ship. Here crew members could let their hair down, drinking, playing cards and having a sing-along. Whenever a celebrity was on board they would come down and entertain the crew in the Pig & Whistle. The Marx Brothers, Gracie Fields, Vera Lynn and Danny Kaye were just some of the famous names we had visiting.

Now, in the late 1950s and early 1960s, the *Mauretania* used to have the best football team on the Atlantic. When we visited New York there was an inter-ocean liner football competition and the winners were presented with the North Atlantic Cup. The *Mauretania* football team thrashed all comers from teams off the French Line's *Liberté* and *Île de France*, the American SS *United States* and SS *America*, the Italian Line's *Italia* and fellow Cunard liners *Queen Mary* and *Queen Elizabeth*. To win the trophy we had to play the German Liner *Bremen*, and we beat them in a tense match at Red Hook Park in Brooklyn. The *Mauretania* football team were now champions of the North Atlantic. Whilst cruising the Caribbean, the *Mauretania* also fielded a fair cricket team, but the West Indian fast bowlers proved to be our undoing in some matches. Occasional boxing tournaments were also arranged on the *Maury* and these proved a popular source of entertainment for the passengers.

Whenever we were at anchor in the Caribbean, the crew went shark fishing off the aft end of the ship. The sharks were attracted to the *Mauretania* as waste food was thrown over the side. At Martinique hammerhead sharks would often circle the ship. On one occasion as Arthur Houchen got a bite he momentarily lost concentration and

❮ Bernard Webb and John Prescott are deep in discussion aboard the *Mauretania* in 1959. (John Owens)

❯ The end of the day and time to relax on the *Mauretania*. Pictured: R. Ailing, T. Clarke, B. Williams, John Owens and Rocky. (John Owens)

his expensive prized fishing rod was swept overboard. The angry shark at the other end of the line, swam around the after anchor chain and the expensive rod floated on the surface just next to the chain. Arthur appealed to the crew for help to retrieve his fishing tackle, offering a reward of $10 for a nimble volunteer to climb down the chain links and recover the rod. With no takers, he increased the reward to $20. However, on seeing the pointed shark fin circling around the anchor chain not a hand went up!

As the temperature rose when heading south on Caribbean cruises, the crew would remove the forward hatch cover on the *Mauretania*. A waterproof tarpaulin sheet would be stretched across this open hatch and firmly tied secure. Sea water was then pumped into the tarpaulin to create an instant crew swimming pool. After having a swim, the crew would bronze themselves in the tropical sunshine, whilst dining on exotic tropical fruits and drinking iced Bacardis.

The *Mauretania* was hired out by Cunard on what were unofficially referred to as 'booze cruises' at the end of a cruising season. Before sailing

from New York a dark coloured truck would arrive at the quayside and a private supply of crates of wine, champagne and hard liquor would be brought aboard under the supervision of some Italian-looking gentlemen. A Mr Shapero and his entourage would arrive in their limousines escorted by well-dressed and fit looking security guards. Members of the 'Association' would soon follow. The baths on the *Mauretania* were filled with ice to cool the bottles of champagne. During the evenings exclusive games of poker would be played, but these cruises were always very peaceful and well-disciplined affairs, with complete respect for Mr Shapero from all on board.

On one occasion on the *Mauretania*, I was taken seriously ill and admitted to hospital with appendicitis. The captain decided to send me home 'D.B.S.' (Disabled British Seaman). After arriving at Pier 90 in New York, I was first down the gangplank off the ship and immediately transferred to the neighbouring *Queen Mary* for return to Southampton. My workmates on the *Mauretania* cheered me off. As I boarded the *Mary* I was greeted by Tony Kinsella, the chief steward, 'Is

∧ A group photograph of the engineer officers of RMS *Mauretania* (John Owens)

that you Owens? From the *Mauretania*, aye? Hope you are not skiving again?' Such was the warm welcome on the *Mary*, but it was meant in good humour.

It was possible to feel really ill on the *Mauretania* during Atlantic crossings each October and November. We would invariably encounter fierce storms with 70ft-high waves. The back of the ship would lift out of the water and it was possible to hear the props going around. On occasions with every door, window and porthole secured, gigantic waves would crash down onto the decks and we would be consumed by water. The *Mauretania* rolled severely to starboard during one storm when the wind changed, so much so that we nearly turned turtle and went on our side. This was a near thing, as we were all frightened as I did not think she would come back. It was a terrifying experience. During these Atlantic storms the passengers were only served sandwiches as it was impossible to cook hot meals. Needless to say even the sandwiches were not eaten.

Stowaways were rare on the *Mauretania*, but they did sneak aboard when loading in port at Southampton or Le Havre whilst heading to New York. They would hide in the lifeboats and then emerge for food and water. These stowaways would stand out and when challenged by the master at arms would be escorted straight to the brig under arrest ready for return.

New York was not always an inviting place, as in the winter sheets of ice would come down the Hudson River. It was difficult to breathe at times as it was so cold. Lookouts on the *Mauretania* would come inside after a watch like blocks of ice.

Like so many of my shipmates who left the *Mauretania*, I left the ship when she transferred to the New York–Naples service. Passenger numbers dropped because she was in direct competition with the modern Italian Line and American Export Line ships. Tips dried up and it was the ruin of the *Mauretania*. Had she maintained and expanded her Caribbean cruising, she may well have survived longer.

It was sad to leave the *Mauretania*, but I was offered an opportunity to be staff captain tiger to look after Captain Storey on the *Queen Mary*. Reluctantly I had to say farewell to the *Maury*.

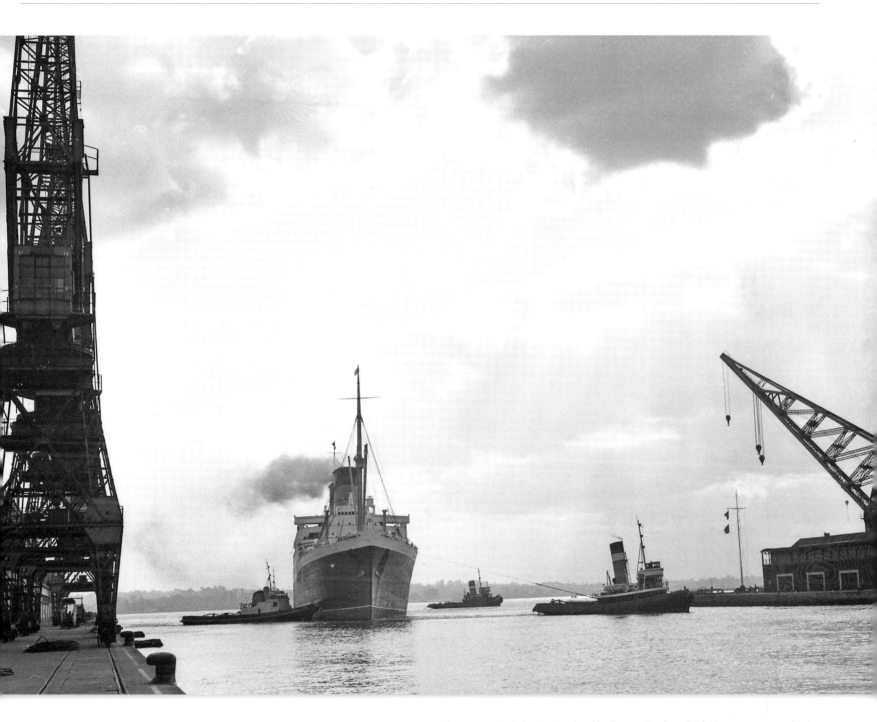

⌃ The *Mauretania* has just arrived in Ocean Dock and is being manoeuvred into Berth 46 by Red Funnel and Alexandra Towing Co. tugs. (Fricker Collection)

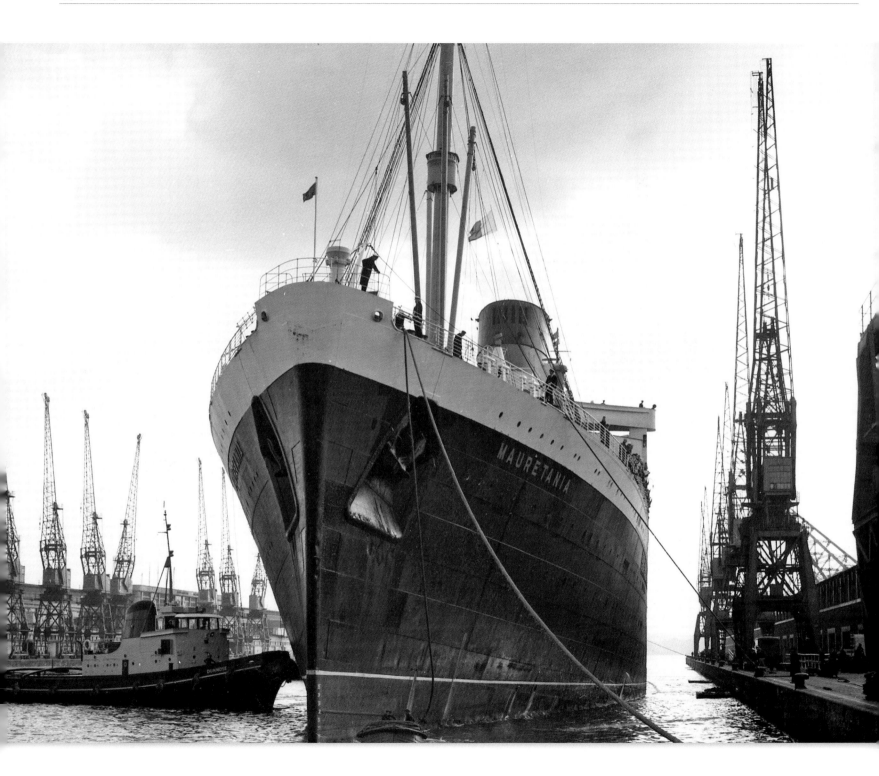

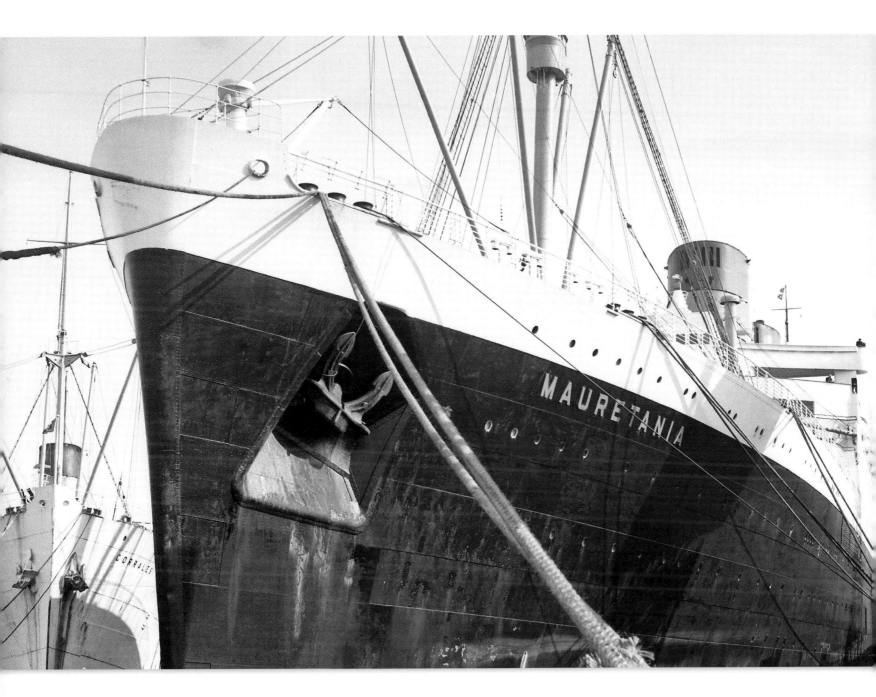

❮ The *Mauretania* has just arrived in Ocean Dock and is being manoeuvred into Berth 46 by the Red Funnel tug *Dunose*. Meanwhile, the crew are busy securing lines ashore. (Fricker Collection)

⌃ The *Mauretania* is now secure and rests next to the passenger-cargo vessel SS *Corrales*, built in 1930. (Fricker Collection)

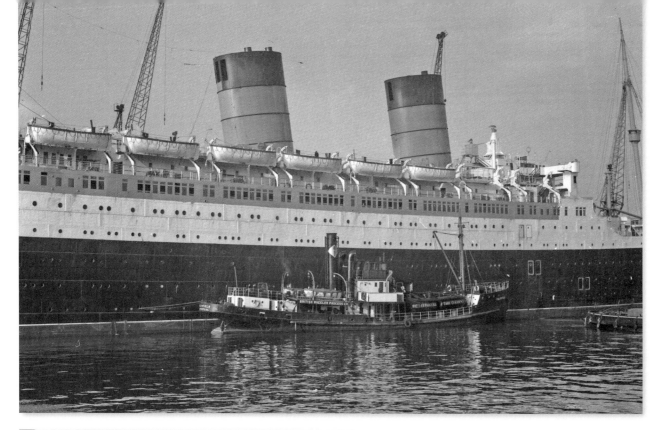

MAURETANIA

3

MAURETANIA
LIVERPOOL

A FINE ADDITION TO A FINE TRADITION — THE NEW "MAURETANIA"....

∧ An artist's impression of what the new *Mauretania* would look like. This original piece of artwork measured a massive 40in by 30in. (Cunard)

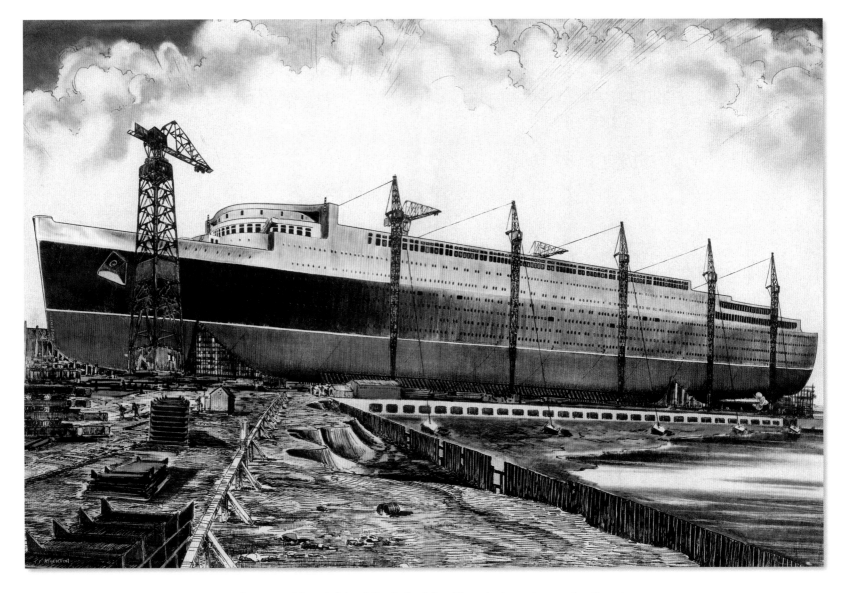

⌃ A pen and ink sketch of the hull of the *Mauretania* under construction at Cammell Laird's shipyard in Birkenhead. (T.F. Atherton/Cunard)

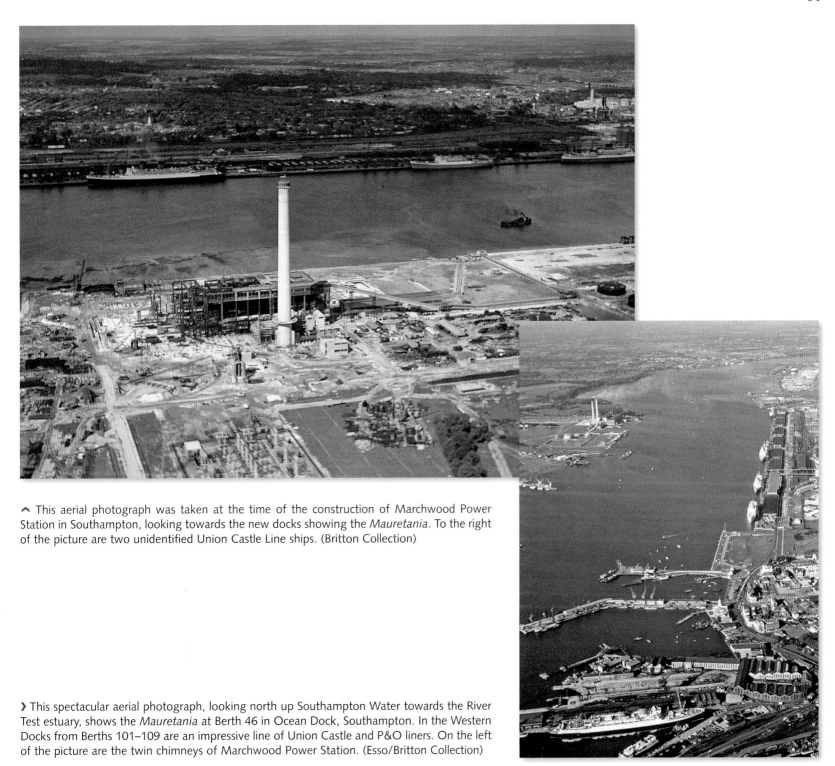

˄ This aerial photograph was taken at the time of the construction of Marchwood Power Station in Southampton, looking towards the new docks showing the *Mauretania*. To the right of the picture are two unidentified Union Castle Line ships. (Britton Collection)

❯ This spectacular aerial photograph, looking north up Southampton Water towards the River Test estuary, shows the *Mauretania* at Berth 46 in Ocean Dock, Southampton. In the Western Docks from Berths 101–109 are an impressive line of Union Castle and P&O liners. On the left of the picture are the twin chimneys of Marchwood Power Station. (Esso/Britton Collection)

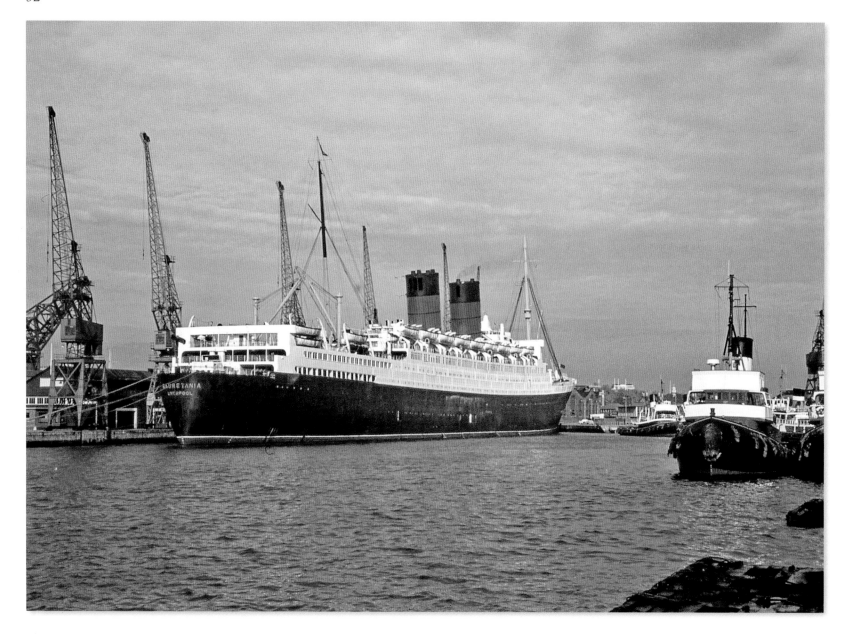

︿ This beautiful picture shows the *Mauretania* painted in classic Cunard livery and berthed in the Ocean Dock, surrounded by Alexandra Towing Co. tugs. (Fricker Collection)

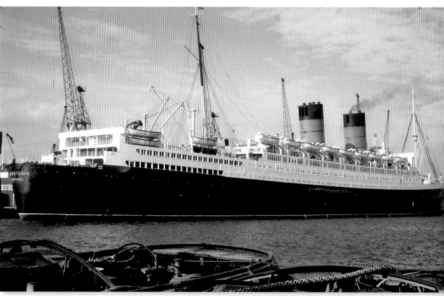

ˆ With a wisp of steam from the funnels, *Mauretania* is carefully manoeuvred into her berth at Ocean Dock, Southampton, by Red Funnel tugs. (Gwyilym R. Davies/Britton Collection)

ˆ Peering across a brace of Alexandra Towing Co. tugs in October 1962, all looks peaceful in Ocean Dock as the *Mauretania* rests at her berth, with the gigantic dock crane standing to attention behind her. (World Ship Society)

˅ A bevy of Alexandra tugs mask the *Mauretania* whilst resting at their usual lay-up at Berth 45 at the end of the Ocean Dock, Southampton, in October 1962. In the foreground is the motor tug *North Isle*. (World Ship Society)

˅ A memorable moment as the *Mauretania* departs from Ocean Dock in Southampton for New York, assisted by Alexandra Towing Co. tug *Canada*. (Barry Eagles)

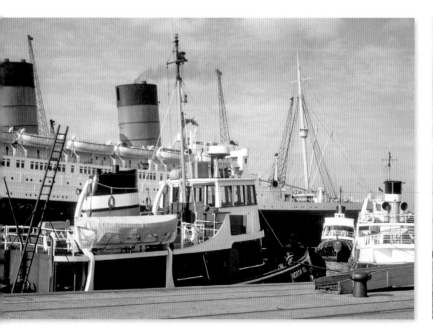

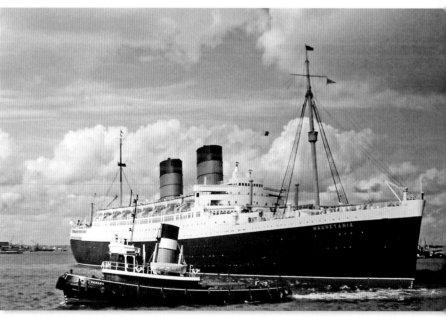

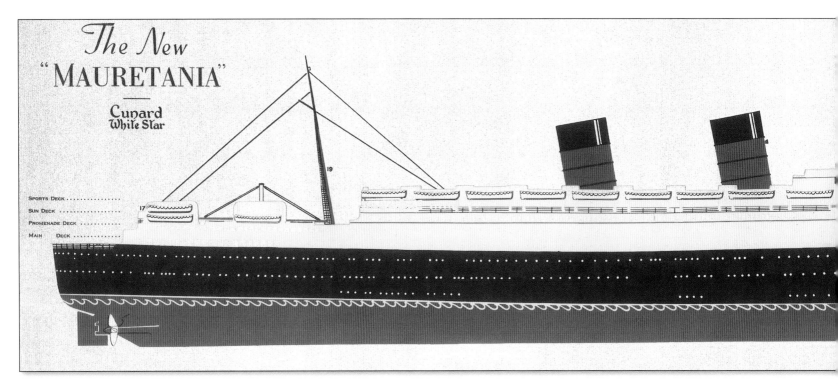

The New
"MAURETANIA"
—
Cunard
White Star

SPORTS DECK
SUN DECK
PROMENADE DECK
MAIN DECK

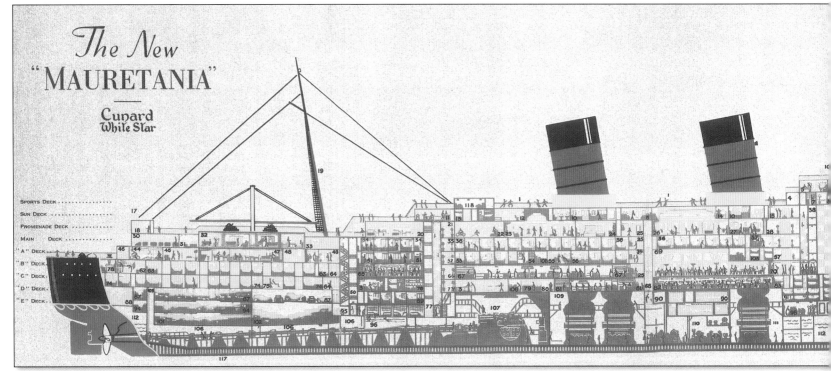

The New
"MAURETANIA"
—
Cunard
White Star

SPORTS DECK
SUN DECK
PROMENADE DECK
MAIN DECK
"A" DECK
"B" DECK
"C" DECK
"D" DECK
"E" DECK

KEY TO SECTIONAL PLAN OF THE NEW 'MAURETANIA'

SPORTS DECK

1	SPORTS DECK
2	SEARCHLIGHT
4	SHELTER
5	CHART ROOM
6	WHEEL HOUSE
7	SERVICE PANTRY
8	THIRD CLASS ENTRANCE
9	CAPTAIN'S ACCOMMODATION
104	WIRELESS DIRECTION FINDER
118	ENGINE CASING

SUN DECK

3	FAN ROOM
10	STATEROOMS
11	CABIN VERANDAH
12	WIRELESS RECEIVING ROOM
13	WIRELESS OPERATORS' ACCOMMODATION
14	CINEMA PROJECTION ROOM
15	CABIN ENTRANCE
16	OFFICERS' ACCOMMODATION

PROMENADE DECK

17	DOCKING BRIDGE
18	AFT WHEEL HOUSE
19	MAIN MAST
20	CABIN SMOKING ROOM
21	CABIN ENTRANCE
22	CABIN GYMNASIUM
23	CABIN LOUNGE
24	LIBRARY
25	PANTRY AND SERVICE LIFT
26	CABIN GRAND HALL
27	WRITING ROOM
28	STAIRCASES AND LIFTS—CABIN ENTRANCE
29	CABIN OBSERVATION LOUNGE

MAIN DECK

3	FAN ROOM
25	PANTRY AND SERVICE LIFT
30	TOURIST PROMENADE
31	AIR-CONDITIONING PLANT
32	TOURIST LOUNGE
33	TOURIST ENTRANCE
34	CABIN BEDROOMS
35	AFTER STAIRCASE AND LIFT
36	CABIN BEDROOMS
37	PURSER'S OFFICE—CABIN ENTRANCE
38	THIRD CLASS STAIRCASES AND LIFT
39	CABIN BEDROOMS
40	THIRD CLASS ENTRANCE
41	FOREMAST
42	CROW'S NEST
43	ANCHOR CAPSTAN AND FO'C'STLE DECK

"A" DECK

25	PANTRY AND SERVICE LIFT
44	TOURIST GYMNASIUM
45	TOURIST ENTRANCE
46	DECK LOCKER
47	TOURIST SMOKING ROOM
48	PANTRY
49	TOURIST ENTRANCE AND PURSER'S OFFICE
51	CABIN BEDROOMS
52	STAIRCASES AND LIFT
53	CABIN BEDROOMS
54	VALET SERVICE ROOM
55	HAIRDRESSER'S SHOP
56	BEDROOMS
57	STAIRCASES AND LIFTS—CABIN ENTRANCE
58	CABIN BEDROOMS
59	THIRD CLASS LOUNGE AND CINEMA
61	CARPENTER'S SHOP

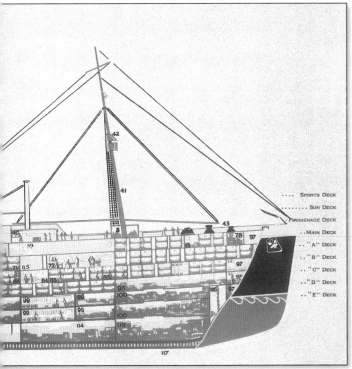

"A" DECK—Continued

78	CAPSTAN MACHINERY
97	STORES
103	STEWARDESSES' ACCOMMODATION
108	AUXILIARY SWITCHBOARD ROOM

"B" DECK

25	PANTRY AND SERVICE LIFT
38	THIRD CLASS STAIRCASES AND LIFT
78	CAPSTAN MACHINERY
62	LAUNDRY
63	TOURIST BEDROOMS
64	STAIRCASES AND LIFT—TOURIST ENTRANCE
65	TOURIST DINING SALOON
66	CABIN ENTRANCE, STAIRCASES AND LIFT
67	CABIN AND TOURIST KITCHEN
69	CABIN RESTAURANT
70	CABIN EMBARKATION HALL
71	THIRD CLASS BEDROOMS
72	THIRD CLASS SMOKING ROOM
85	THIRD CLASS ENTRANCE

"C" DECK

3	FAN ROOM
74	TOURIST BEDROOMS
75	HAIRDRESSER'S SHOP
76	ENGINEER OFFICERS' ACCOMMODATION
77	STAIRCASES AND LIFT
79	LINEN SORTING ROOM
80	STORES ENTRANCE
81	THIRD CLASS KITCHENS
82	THIRD CLASS DINING SALOON
83	THIRD CLASS BEDROOMS
84	HAIRDRESSER'S SHOP
97	STORES
108	AUXILIARY SWITCHBOARD ROOM

"D" DECK

3	FAN ROOM
89	TOURIST BEDROOMS
91	THIRD CLASS BEDROOMS

"E" DECK

50	TOURIST STAIRCASES AND LIFT
68	SERVICE LIFT
95	LIFT MACHINERY
96	CABIN SWIMMING POOL

MACHINERY AND HOLDS

87	GARAGE
88	STEERING GEAR
90	COLD STORES
94	No. 5 HOLD 'TWEEN DECK GENERAL CARGO
98	REFRIGERATING MACHINERY
99	REFRIGERATED CARGO
100	No. 1 HOLD 'TWEEN DECK GENERAL CARGO
101	No. 5 HOLD GENERAL CARGO
102	No. 4 HOLD GENERAL CARGO
105	SHAFT ESCAPE
106	SHAFT AND SHAFT TUNNEL
107	MAIN ENGINE ROOM
109	AFTER BOILER ROOM
110	AUXILIARY ENGINE ROOM AND POWER STATION
111	FORWARD BOILER ROOM
112	DOMESTIC WATER TANKS
113	No. 3 HOLD REFRIGERATED AND GENERAL CARGO
114	No. 2 HOLD REFRIGERATED AND GENERAL CARGO
115	No. 1 HOLD GENERAL CARGO
116	CHAIN LOCKER
117	DOUBLE BOTTOM AND TANKS

❮ Painted cross-sectional plan of the *Mauretania*, with key.

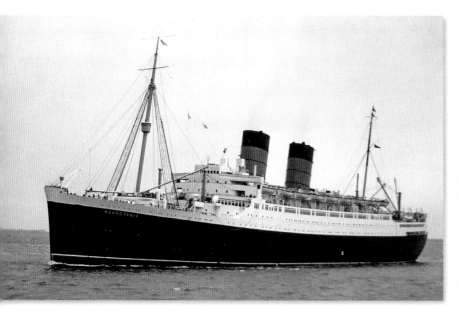

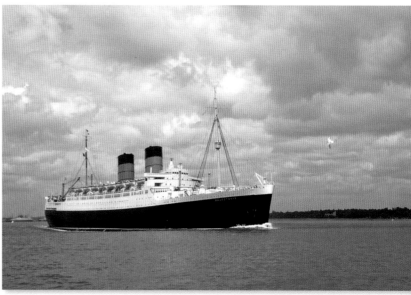

⌃ In regal grandeur, the *Mauretania* slowly sails across the Solent between Ryde Pier Head and Cowes, off the Isle of Wight. (Britton Collection)

⌄ This busy picture shows the *Mauretania* passing a Portsmouth-bound light cruiser, possibly HMS *Tiger*, which was equipped with 6in guns. The yachts give the location away as Cowes on the Isle of Wight. The picture was taken *c.*1957. (George Garwood/World Ship Society)

⌃ The majestic *Mauretania* was always a mesmerising sight as she sailed down Southampton Water with a snow white bow wave. Photographer Phil Fricker of Cowes captured her passing Netley in all her glory in original classic Cunard livery, complete with a seagull swooping down in the foreground. (Fricker Collection)

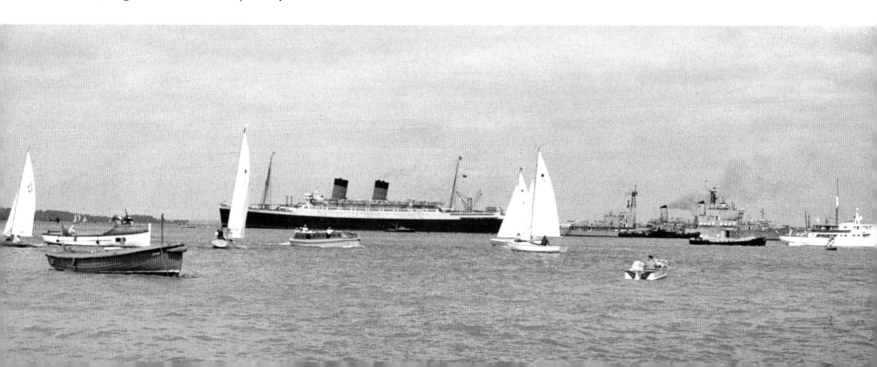

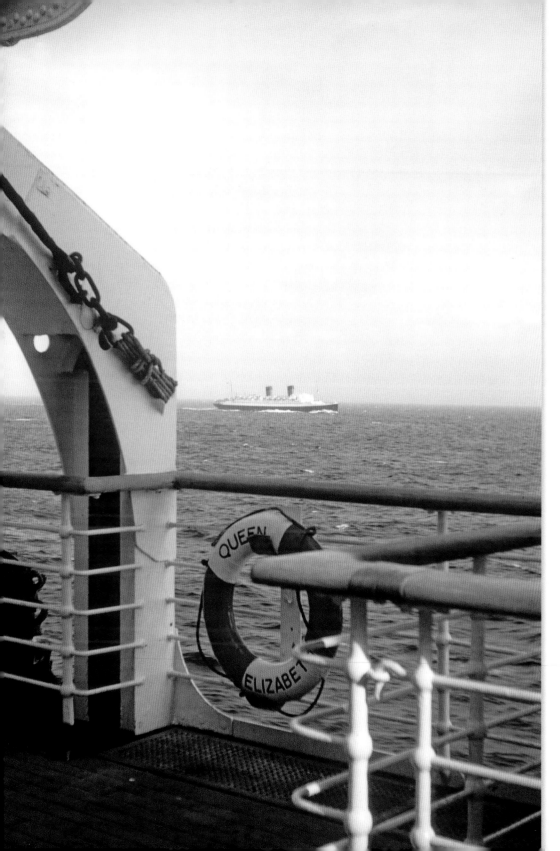

⌃ Heading west from Cobh and looking forward across the bows of the *Mauretania*, there is nothing but the clear blue ocean of the North Atlantic. (Barry Eagles)

⌄ A view from the starboard running bridge looking aft across the lifeboats showing those wonderful twin funnels. (Barry Eagles)

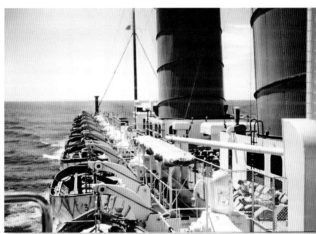

❮ Framed to perfection in the mid-Atlantic, the *Mauretania* approaches RMS *Queen Elizabeth*. (Britton Collection)

> Focus on the aft funnel. (Barry Eagles)

∨ Looking forward along the starboard side of the ship mid-Atlantic, one can almost feel the *Mauretania* rolling as those two funnels belch out clouds of smoky black exhaust fumes. (Britton Collection)

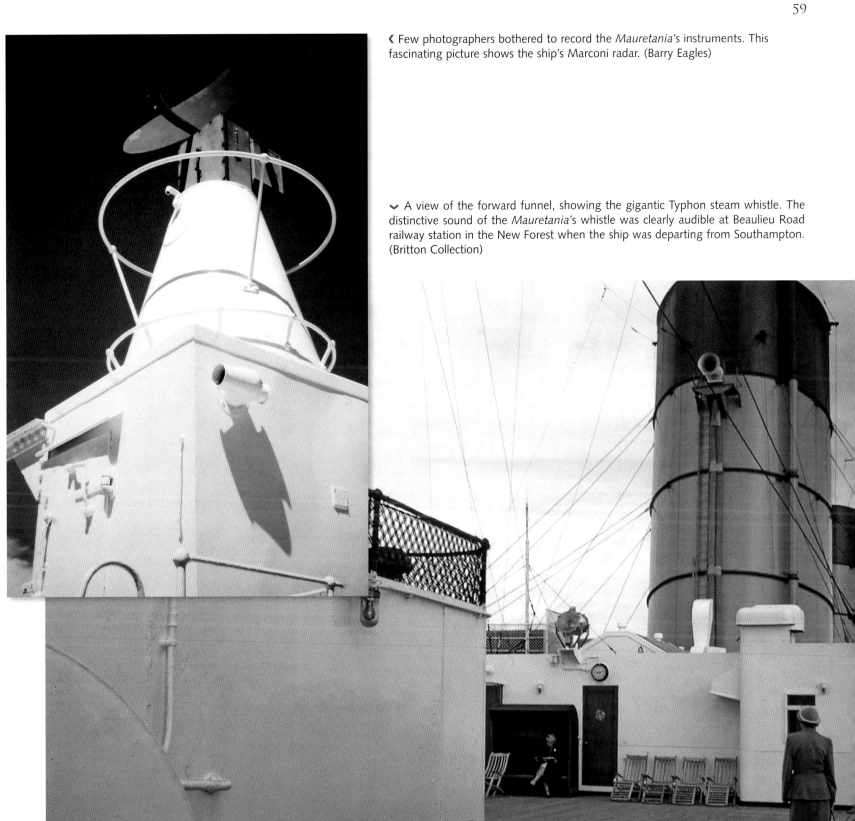

❮ Few photographers bothered to record the *Mauretania*'s instruments. This fascinating picture shows the ship's Marconi radar. (Barry Eagles)

❯ A view of the forward funnel, showing the gigantic Typhon steam whistle. The distinctive sound of the *Mauretania*'s whistle was clearly audible at Beaulieu Road railway station in the New Forest when the ship was departing from Southampton. (Britton Collection)

MAURETANIA
R·M·S

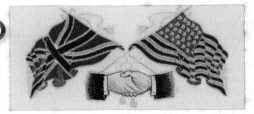

HANDS ACROSS THE SEA.

WOVEN IN SILK.

R.M.S. MAURETANIA.

THIS MEDALLION
IS MADE FROM METAL
FROM THE OLD
"MAURETANIA"
1906-1935

R.M.S.
"MAURETANIA"

GUIDE TO
ACCOMMODATION
AND GENERAL
INFORMATION
FOR PASSENGERS

CUNARD WHITE STAR

Form A 1"2.

THE CUNARD STEAM-SHIP COMPANY LIMITED

COURSE BOOK
(ATLANTIC SERVICE).
(24 Leaf).

SHIP "_Mauretania_"

To be returned on completion of Voyage to the Marine
Superintendent, Cunard Building, Liverpool.

400—12/61—L.P. 41/253

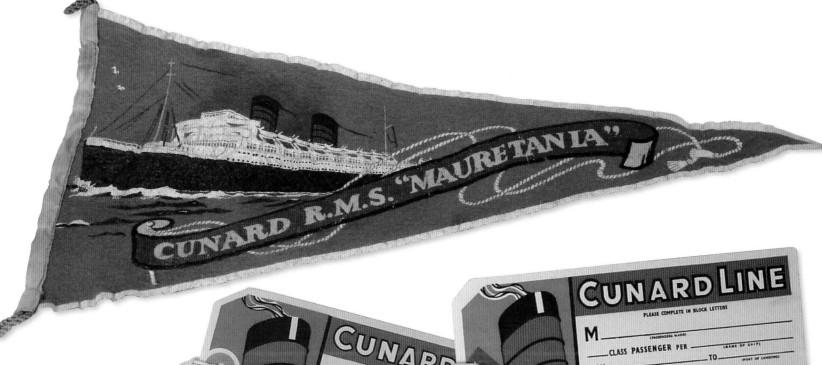

Assorted items of interest from the *Mauretania*. The commemorative medallion was made from metal from the original *Mauretania* (1906–35).

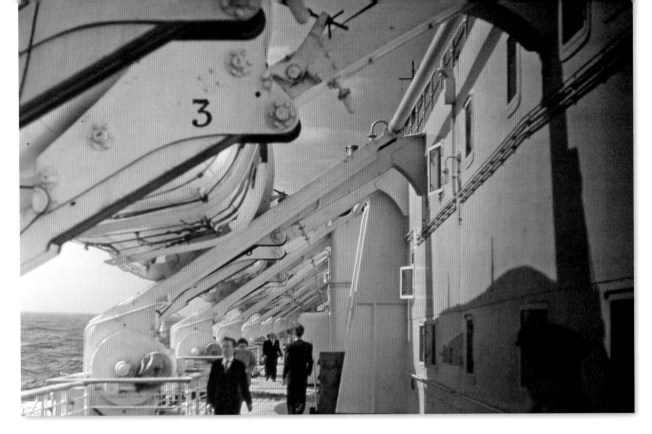

❮ A mid-Atlantic view looking down the lifeboat deck on the *Mauretania*. Note the passengers' smart dress with shirts, ties and jackets. (Britton Collection)

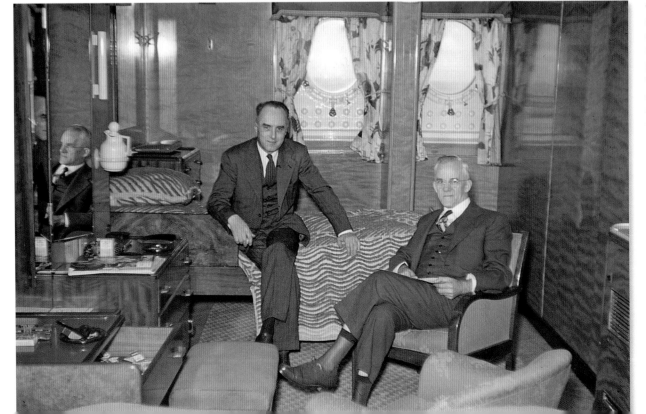

❮ Two gentlemen passengers are pictured relaxing in their cabin aboard the *Mauretania*. Note the base-riveted twin portholes, varnished panelling with matching bedside cabinet and dresser, mounted water jug and matching sky blue furnishing. (Britton Collection)

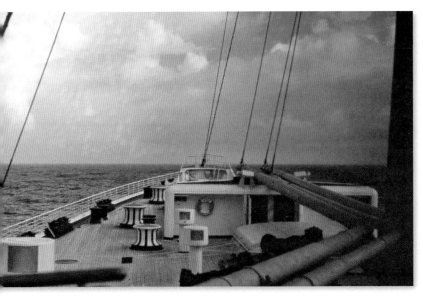

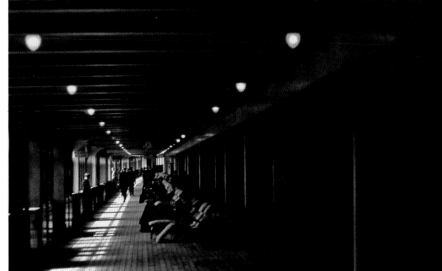

^ The *Mauretania*'s prow is cutting rough waves as she approaches the Nantucket Shoals off the east coast of the USA and the lookouts are no doubt peering ahead through their binoculars to spot the lightship. (Britton Collection)

^ The clock reads 11.40 a.m. as passengers relax and enjoy the spectacular view looking down the promenade deck. (Britton Collection)

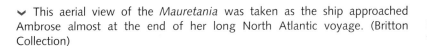

⌄ This aerial view of the *Mauretania* was taken as the ship approached Ambrose almost at the end of her long North Atlantic voyage. (Britton Collection)

⌄ Gracious Lady! The *Mauretania* slowly passes the 333ft-high Statue of Liberty, which first opened in 1886 and, in the heyday of the transatlantic liner, welcomed thousands of ships and millions of passengers each year. (Britton Collection)

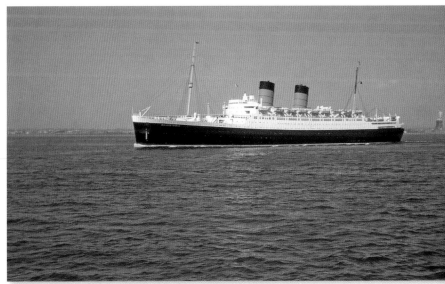

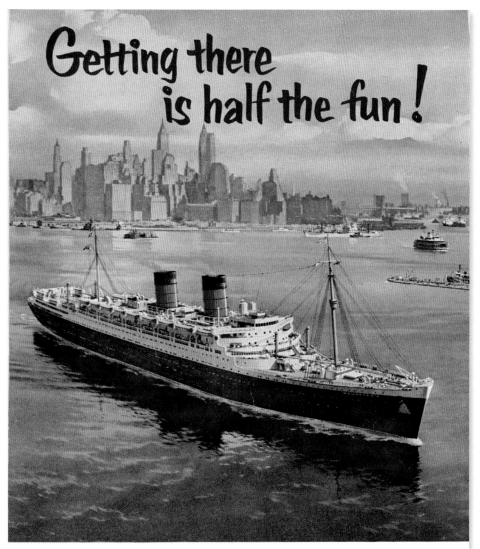

Europe-bound—the magnificent Mauretania, proud successor to one of the most famous names
in transatlantic travel . . . preferred by those who seek the luxury of the world's largest
liners on a more intimate scale . . . and who treasure an extra day at sea to enjoy
Cunard's wonderful food and service . . . to join in the sparkling round of happy shipboard
diversions . . . or simply to relax in the contented conviction that "Getting There *is* Half the Fun!"

See your Cunard-authorized Travel Agent and . . . **GO CUNARD**

QUEEN ELIZABETH · QUEEN MARY · MAURETANIA · CARONIA · BRITANNIC · MEDIA · PARTHIA
SAXONIA · FRANCONIA · SCYTHIA · SAMARIA · ASCANIA

An 18" x 22" color reproduction of this painting of the Mauretania (without the advertising text and suitable for framing) will be sent upon request
Write: Cunard Line, 25 Broadway, Dept. 1, New York 4, N. Y.

⌃ 'Getting there is half the fun! Go
Cunard.' A Cunard publicity advert showing
the *Mauretania* sailing from New York.

❯ Front cover of the *Mauretania* pamphlet
for Sunshine Cruises to the West Indies and
South America, 1950–51.

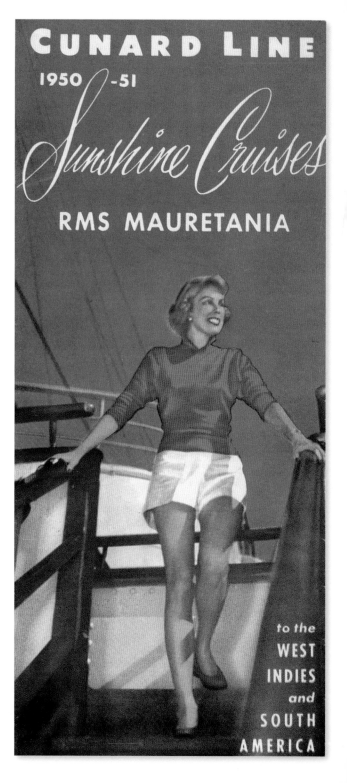

CUNARD LINE
1950 -51
Sunshine Cruises
RMS MAURETANIA

to the
WEST
INDIES
and
SOUTH
AMERICA

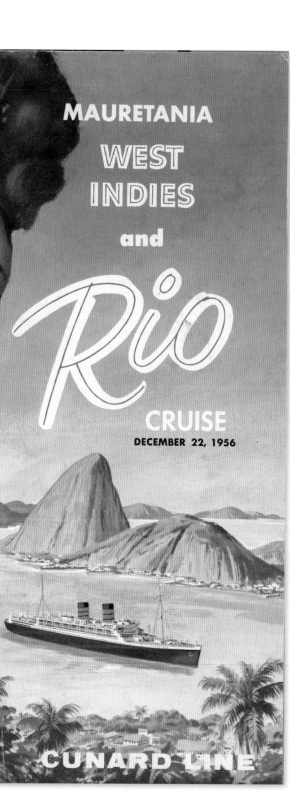

⌄ Front cover of the *Mauretania* pamphlet for Sunshine Cruises – November 1951.

❯ Front cover of the Sunshine Cruise pamphlet of 1956.

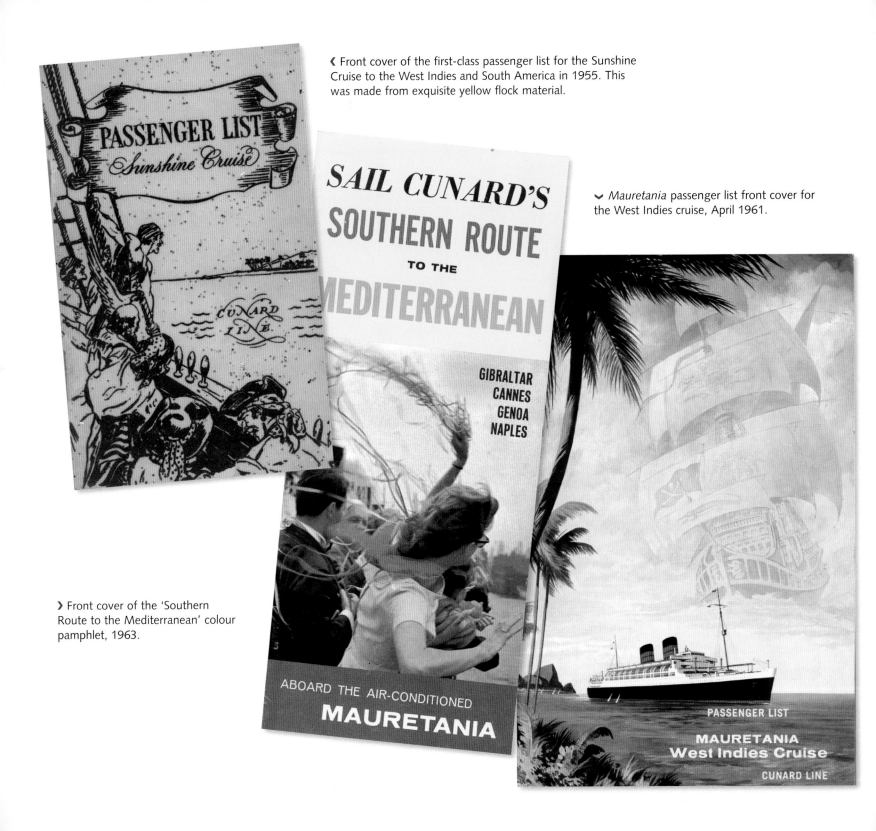

❮ Front cover of the first-class passenger list for the Sunshine Cruise to the West Indies and South America in 1955. This was made from exquisite yellow flock material.

❯ Front cover of the 'Southern Route to the Mediterranean' colour pamphlet, 1963.

❮ *Mauretania* passenger list front cover for the West Indies cruise, April 1961.

PASSENGER LIST
Sunshine Cruise

CUNARD LINE

SAIL CUNARD'S
SOUTHERN ROUTE
TO THE
MEDITERRANEAN

GIBRALTAR
CANNES
GENOA
NAPLES

ABOARD THE AIR-CONDITIONED
MAURETANIA

PASSENGER LIST
MAURETANIA
West Indies Cruise
CUNARD LINE

R.M.S. "Mauretania"
Cunard Line

Mediterranean
Cruise

Thomas S. Hamilton, Cruise Director

presents his compliments

and requests the pleasure of your company

for Cocktails in the

Hideaway, "A" Deck Aft

from 6.15 to 7.00 p.m.,

Thursday, 21st May, 1964

CUNARD LINE R.M.S. "MAURETANIA"

Captain W. J. Law, R.D., A.D.C., R.N.R.

presents his compliments

and requests the pleasure of your company for

Cocktails in the Grand Hall

Promenade Deck (forward entrance)

from 7.45 to 8.30 p.m.,

Sunday, 2nd May, 1965

CUNARD LINE R.M.S. "MAURETANIA"

The Master, Captain J. Treasure-Jones,
R.D., R.N.R.

presents his compliments

and requests the pleasure of your company for

Cocktails in the Grand Hall

Promenade Deck (forward entrance)

from 6.00 to 6.45 p.m.,

Monday, 18th May, 1964

CUNARD LINE R.M.S. "MAURETANIA"

Staff Chief Engineer A. D. Cawte

presents his compliments

and requests the pleasure of your company

at **6.15 PM** *today*

in his Cabin on "C" Deck Aft

Your Steward will direct you to the Cabin

⌃ *Mauretania* invitation cards.

"Mauretania"

Launch at the yard of
Cammell Laird & Co Limited
Birkenhead

Thursday July 28 1938

Naming ceremony performed by
Lady Bates

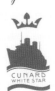

CUNARD
WHITE STAR

"Mauretania"

A PICTORIAL SOUVENIR
OF THE NEWEST ADDITION
TO THE CUNARD WHITE STAR FLEET

PRINTED IN GENUINE GRAVURE

CUNARD
WHITE STAR

⌃ Cunard White Star Line pictorial souvenir booklet front cover.

"Mauretania"

❭ The cover of the launch booklet.

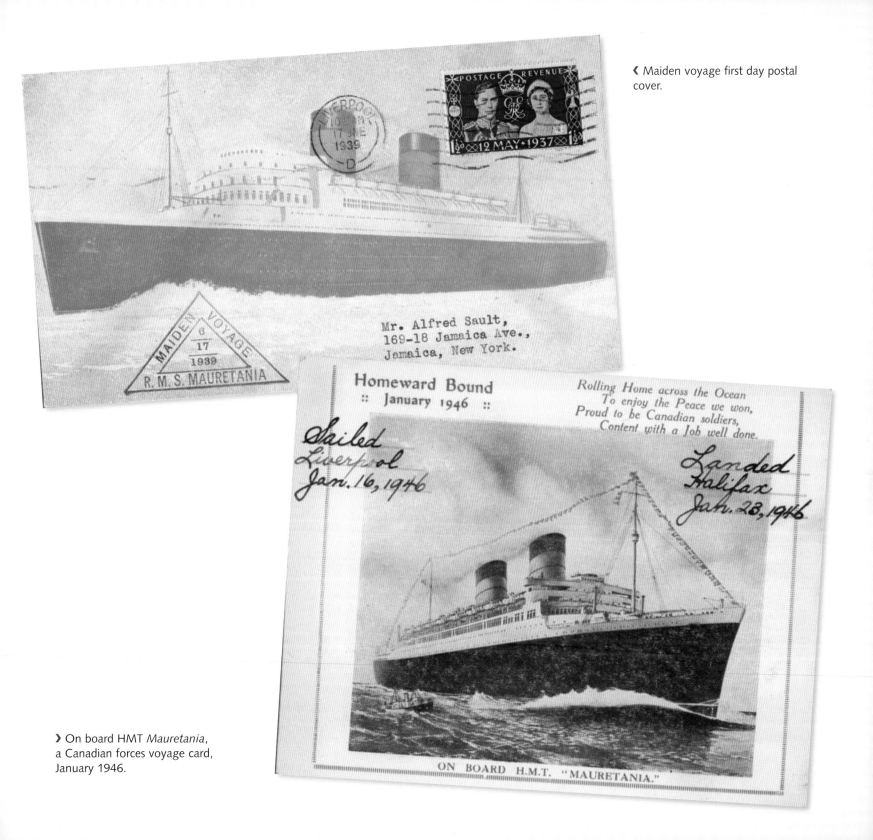

❮ Maiden voyage first day postal cover.

POSTAGE · REVENUE
12 MAY · 1937

LIVERPOOL
10 AM
17 JNE
1939
D

MAIDEN VOYAGE
6
17
1939
R.M.S. MAURETANIA

Mr. Alfred Sault,
169-18 Jamaica Ave.,
Jamaica, New York.

Homeward Bound
:: January 1946 ::

Rolling Home across the Ocean
To enjoy the Peace we won,
Proud to be Canadian soldiers,
Content with a Job well done.

Sailed
Liverpool
Jan. 16, 1946

Landed
Halifax
Jan. 28, 1946

ON BOARD H.M.T. "MAURETANIA."

❯ On board HMT *Mauretania*, a Canadian forces voyage card, January 1946.

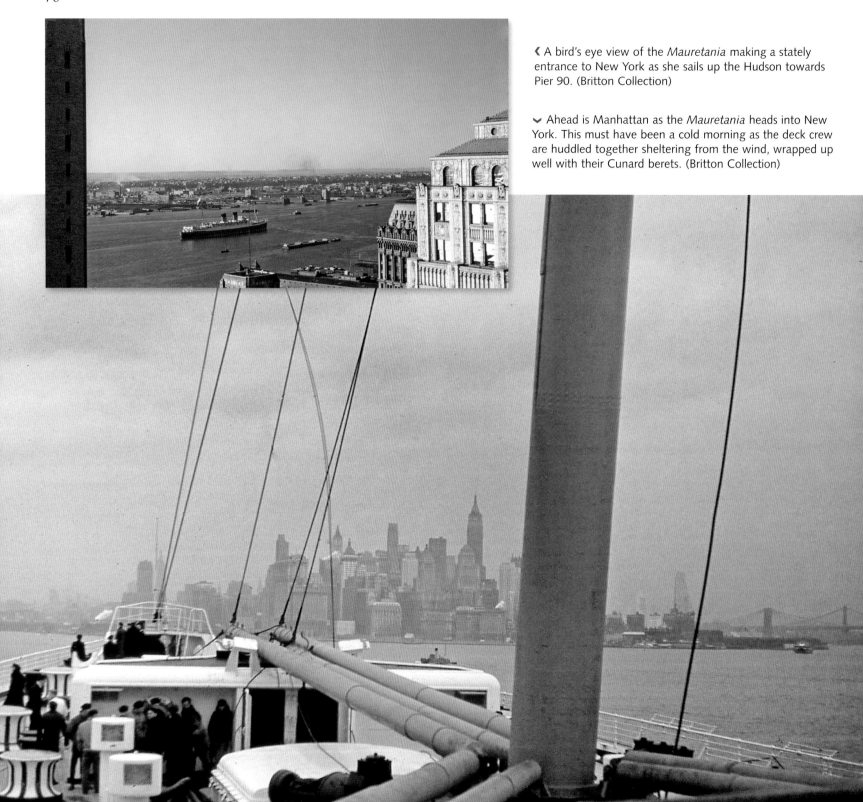

❮ A bird's eye view of the *Mauretania* making a stately entrance to New York as she sails up the Hudson towards Pier 90. (Britton Collection)

❱ Ahead is Manhattan as the *Mauretania* heads into New York. This must have been a cold morning as the deck crew are huddled together sheltering from the wind, wrapped up well with their Cunard berets. (Britton Collection)

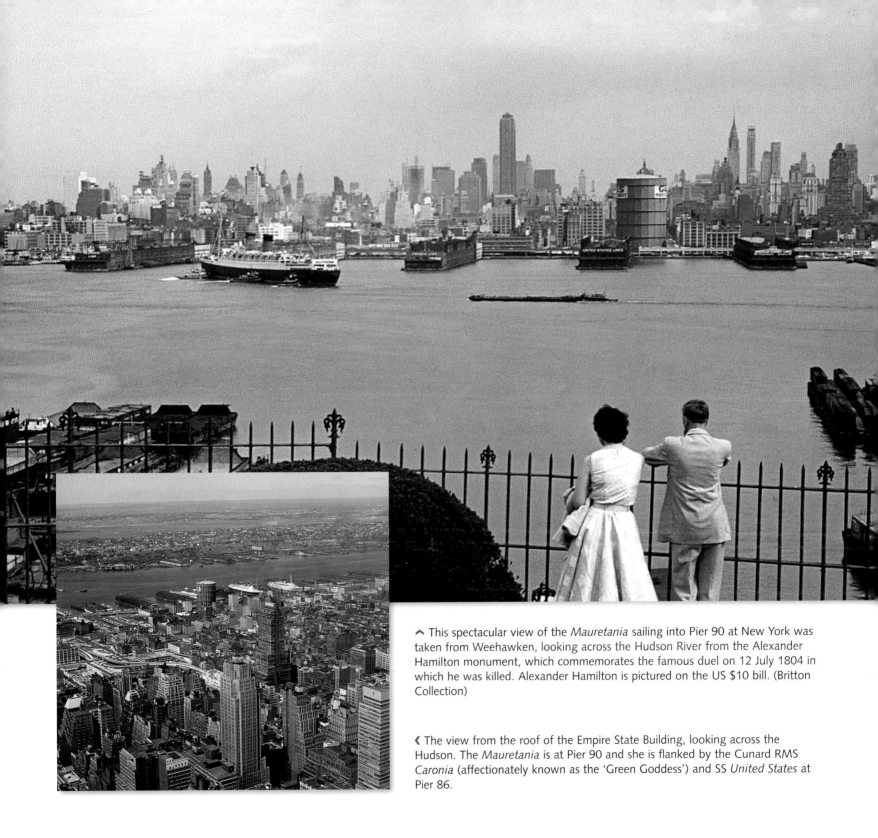

⌃ This spectacular view of the *Mauretania* sailing into Pier 90 at New York was taken from Weehawken, looking across the Hudson River from the Alexander Hamilton monument, which commemorates the famous duel on 12 July 1804 in which he was killed. Alexander Hamilton is pictured on the US $10 bill. (Britton Collection)

❮ The view from the roof of the Empire State Building, looking across the Hudson. The *Mauretania* is at Pier 90 and she is flanked by the Cunard RMS *Caronia* (affectionately known as the 'Green Goddess') and SS *United States* at Pier 86.

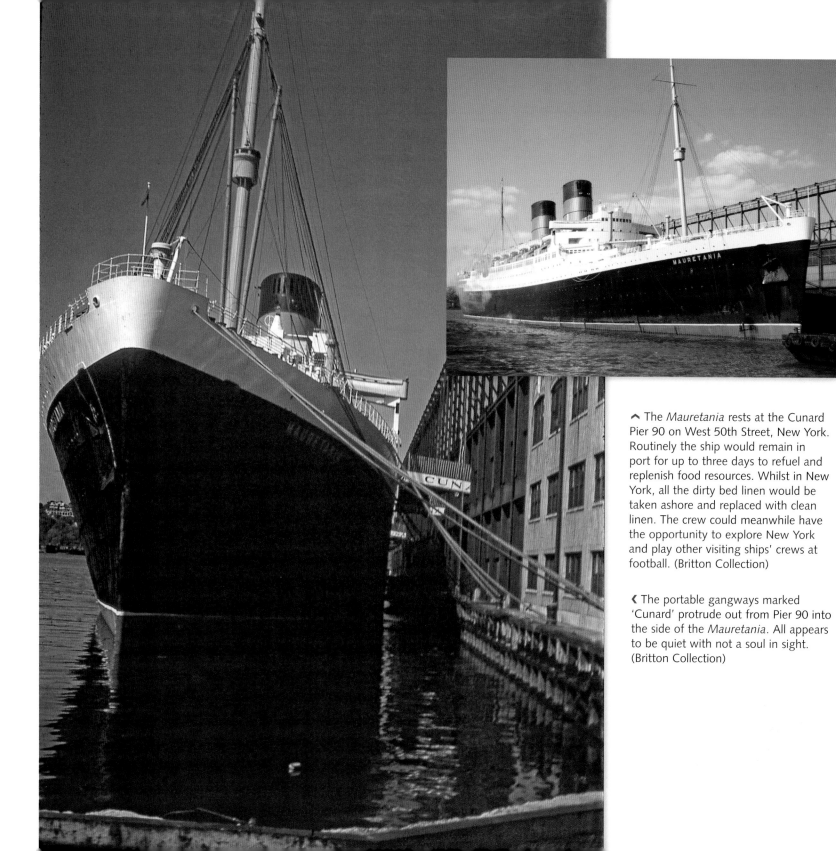

⌃ The *Mauretania* rests at the Cunard Pier 90 on West 50th Street, New York. Routinely the ship would remain in port for up to three days to refuel and replenish food resources. Whilst in New York, all the dirty bed linen would be taken ashore and replaced with clean linen. The crew could meanwhile have the opportunity to explore New York and play other visiting ships' crews at football. (Britton Collection)

❮ The portable gangways marked 'Cunard' protrude out from Pier 90 into the side of the *Mauretania*. All appears to be quiet with not a soul in sight. (Britton Collection)

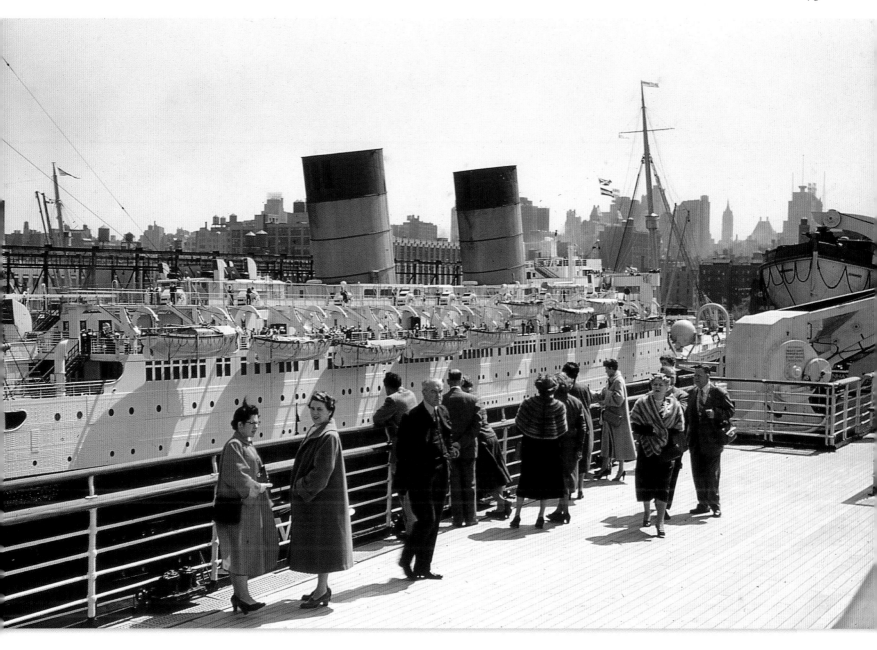

⌃ Furs abound on the ladies in this 1950s picture, as passengers on a neighbouring liner admire the graceful and handsome design of the *Mauretania* as she rests at Pier 90. (Britton Collection)

❯ What a marvellous spectacle this scene was for New Yorkers. On the left at Pier 88 at West 48th Street is the post-war French Line flagship *Liberté* and on the right at Pier 90 is the *Mauretania*. The *Liberté* briefly held the Atlantic Blue Riband in the 1930s as the German *Europa*. (Britton Collection)

⌄ Departure time from Pier 90 at New York as the *Mauretania* is gently guided out by a Moran tugboat. (Britton Collection)

❯ The red funnels of the *Mauretania* are reflected in the waters of the Hudson River. She has reversed out from Pier 90 assisted by Moran tugs and is just about to commence the swing process so that the ship is facing the right direction to sail downstream towards the narrows. (Britton Collection)

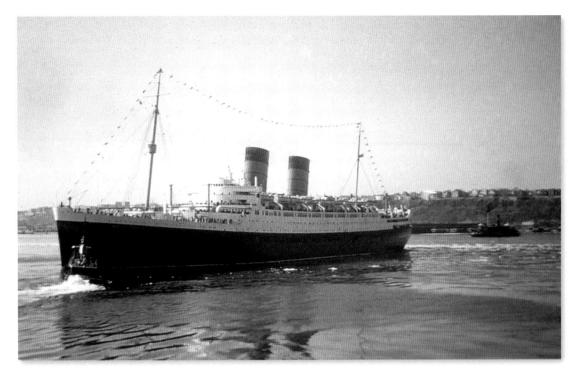

❯ In this shot from 1955, well-wishers catch a last glimpse of the *Mauretania* as she sails down the Hudson escorted by a Moran tug. (Britton Collection)

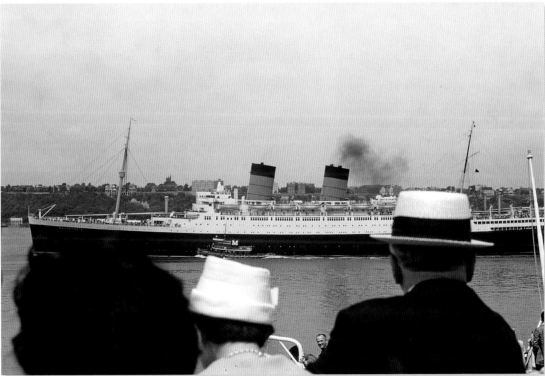

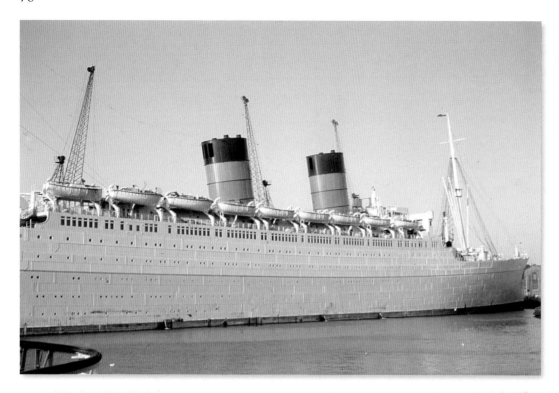

❮ When the *Mauretania* emerged from her overhaul in the King George V Dock at Southampton in October 1962, her new paint work was in three shades of Cunard cruising-green livery similar to the *Caronia*. She is seen here at Berth 46 in Ocean Dock, Southampton. Not all ship lovers or the crew of the *Mauretania* appreciated this colour scheme. (Britton Collection)

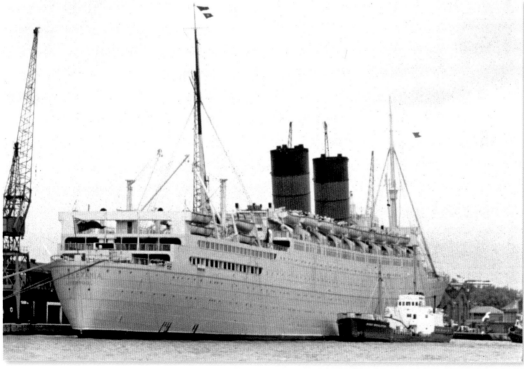

❮ Although this picture appears to show the *Mauretania* in Cunard cruising-white livery, it is merely a trick of the light. She was never painted white and only ever carried the classic and cruising-green liveries. (World Ship Society)

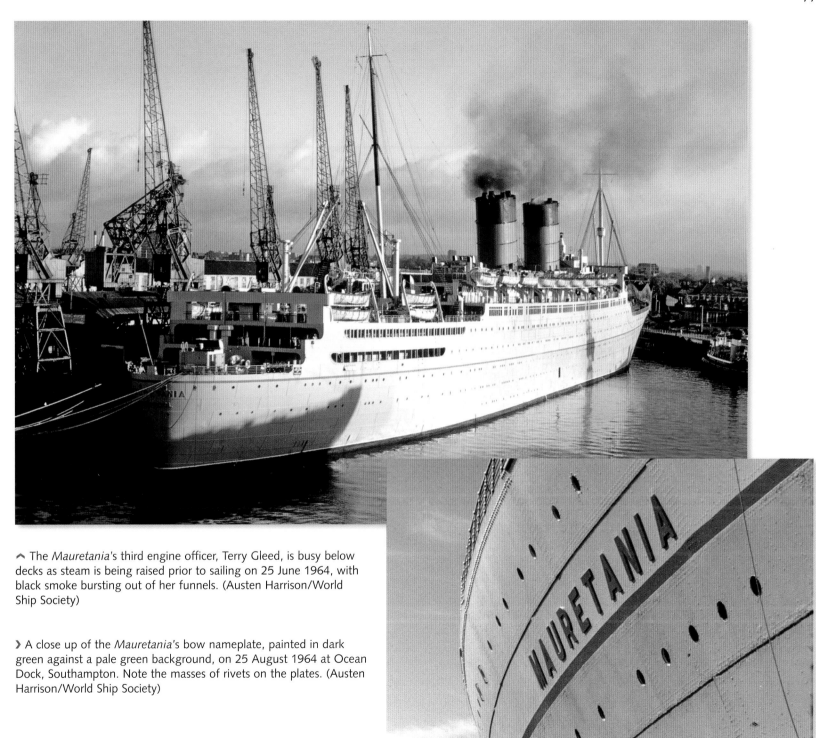

⌃ The *Mauretania*'s third engine officer, Terry Gleed, is busy below decks as steam is being raised prior to sailing on 25 June 1964, with black smoke bursting out of her funnels. (Austen Harrison/World Ship Society)

❯ A close up of the *Mauretania*'s bow nameplate, painted in dark green against a pale green background, on 25 August 1964 at Ocean Dock, Southampton. Note the masses of rivets on the plates. (Austen Harrison/World Ship Society)

MAURETANIA—MARCONI WIRELESS TELEPHONE AND WIRELESS TELEGRAPH EQUIPMENT

How to make a telephone call
OR
SEND A WIRELESS MESSAGE
FROM R.M.S. MAURETANIA

The main accepting offices for wireless messages and the booking of radio-telephone calls are situated as follows :—

FOR WIRELESS MESSAGES—The Radio Office at the starboard side of the Sun Deck.

FOR RADIOTELEPHONE CALLS—The Purser's Bureaux in the Cabin, Tourist and Third Class accommodation.

Full information in regard to the various wireless telegraph and telephone services available can be obtained at these offices. Telegraph forms will be found on the writing desks and should you wish to telegraph or telephone to some friend or relative ashore the following brief summary of the facilities available will assist you in your choice of service.

RADIOTELEPHONE CALLS

Four special radiotelephone booths are provided :
1 adjacent to Cabin Purser's Bureau,
1 adjoining Tourist Purser's Bureau,
1 next to Third Class Purser's Bureau,
and the fourth in the Radio Office.

To book a radiotelephone call, all you have to do is give particulars of the call required to the official on duty at the Purser's Bureau and he will make the arrangements necessary for you to take up the call at the adjacent telephone booth.

The charges for telephone calls depend on the position of the ship, and to some extent on the amount of landline communication involved. For calls from the ship to subscribers in Great Britain and in the New York zone the charges are as under :—

TO GREAT BRITAIN
From the Eastern Atlantic, 12/- per minute, minimum 36/-
From the Western Atlantic, 24/- per minute, minimum 72/-

TO NEW YORK ZONE
From the Western Atlantic $3 per minute, minimum $9
From the Eastern Atlantic $6 per minute, minimum $18

⌃ How to make a telephone call or send a wireless message from aboard the *Mauretania*.

❯ Front cover of the *Mauretania* pamphlet for Sunshine Cruises to the West Indies and South America in 1952–53.

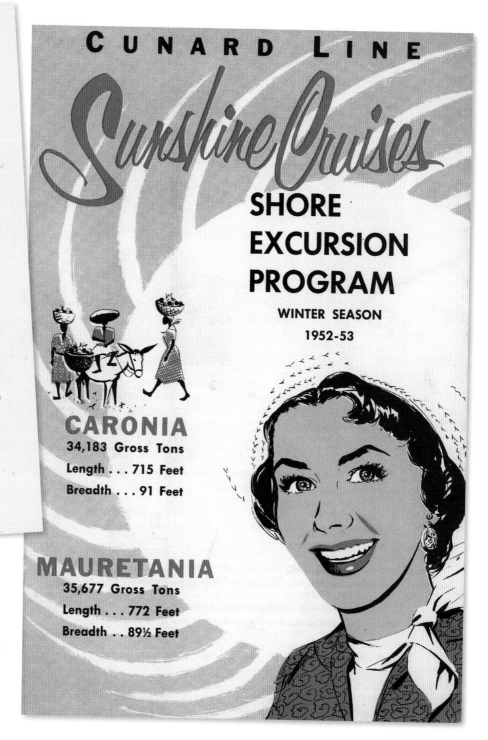

CUNARD LINE
Sunshine Cruises
SHORE EXCURSION PROGRAM
WINTER SEASON
1952-53

CARONIA
34,183 Gross Tons
Length . . . 715 Feet
Breadth . . . 91 Feet

MAURETANIA
35,677 Gross Tons
Length . . . 772 Feet
Breadth . . 89½ Feet

Itinerary of the Sunshine Cruise to the West Indies and South America of 1955.

R.M.S. Mauretania

CRUISE TO

WEST INDIES

and

SOUTH AMERICA

Saturday, January 29, 1955

RETURNING TO NEW YORK

Wednesday, February 16, 1955

CRUISE ITINERARY				
PORT	MILEAGE	ARRIVE		DEPART
NEW YORK			(embark 2 p.m. to 4:30 p.m.)	Sat. Jan. 29
ST. THOMAS	1438	Tues. Feb. 1, p.m.		Tues. Feb. 1, p.m.
MARTINIQUE	317	Wed. Feb. 2, p.m.		Wed. Feb. 2, p.m.
GRENADA	161	Thurs. Feb. 3, a.m.		Thurs. Feb. 3, p.m.
LA GUAIRA	318	Fri. Feb. 4, a.m.		Fri. Feb. 4, p.m.
CURACAO	148	Sat. Feb. 5, a.m.		Sat. Feb. 5, p.m.
CRISTOBAL	691	Mon. Feb. 7, a.m.		Tues. Feb. 8, a.m.
KINGSTON	554	Wed. Feb. 9, a.m.		Wed. Feb. 9, p.m.
PORT-AU-PRINCE	278	Thurs. Feb. 10, a.m.		Thurs. Feb. 10, p.m.
HAVANA	657	Sat. Feb. 12, a.m.		Sun. Feb. 13, a.m.
NASSAU	381	Mon. Feb. 14, a.m.		Mon. Feb. 14, p.m.
NEW YORK	961	Wed. Feb. 16, p.m.		

The Cunard Steam-Ship Company Limited

R.M.S.

MAURETANIA

CRUISE TO

WEST INDIES AND SOUTH AMERICA

———

LIST OF OFFICERS

Captain — C. S. WILLIAMS

Staff Captain — W. J. LAW, R.D., R.N.R.

Chief Engineer........G. W. BAIN

Chief Officer........J. W. WOOLFENDEN, D.S.C., R.D., R.N.R.

Staff Chief Engineer........J. A. MacGREGOR

Purser..........V. M. PHILLIPS

SurgeonS. GEORGE, M.B., Ch.B.

Staff Purser..........B. JENKINS

Chief Steward......P. G. BURRAGE

CRUISE STAFF

•

Cruise Director
MR. V. OGLEY

———

Lecturer
MR. W. LOWE

———

Social Directresses
MISS J. LINDGREN
MISS A. H. JOSEY

Assistant Cruise Directors

MR. W. R. BROWN
MR. R. EAGLES
MR. F. HINSDALE

MR. D. STUART

MR. W. HUDGINS
MR. J. P. JONES
MR. G. MONDS

Photography
CRUISE PHOTOGRAPHY LIMITED

Entertainment
UNDER DIRECTION OF
NAT. M. ABRAMSON

Divine Service will be conducted by the ship's Officials and a Priest of the Roman Catholic Church, Msgr. Francis B. Donnelly, will celebrate Holy Mass.

The crew of the Sunshine Cruise to the West Indies and South America of 1955.

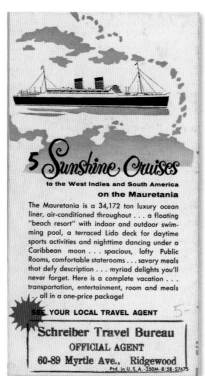

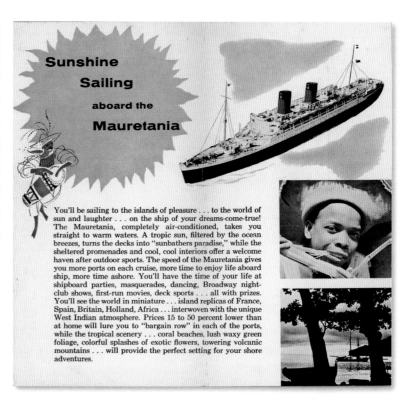

You'll be sailing to the islands of pleasure . . . to the world of sun and laughter . . . on the ship of your dreams-come-true! The Mauretania, completely air-conditioned, takes you straight to warm waters. A tropic sun, filtered by the ocean breezes, turns the decks into "sunbathers paradise," while the sheltered promenades and cool, cool interiors offer a welcome haven after outdoor sports. The speed of the Mauretania gives you more ports on each cruise, more time to enjoy life aboard ship, more time ashore. You'll have the time of your life at shipboard parties, masquerades, dancing, Broadway night-club shows, first-run movies, deck sports . . . all with prizes. You'll see the world in miniature . . . island replicas of France, Spain, Britain, Holland, Africa . . . interwoven with the unique West Indian atmosphere. Prices 15 to 50 percent lower than at home will lure you to "bargain row" in each of the ports, while the tropical scenery . . . coral beaches, lush waxy green foliage, colorful splashes of exotic flowers, towering volcanic mountains . . . will provide the perfect setting for your shore adventures.

Various front covers and other details from pamphlets of the Sunshine Cruises to the West Indies and South America.

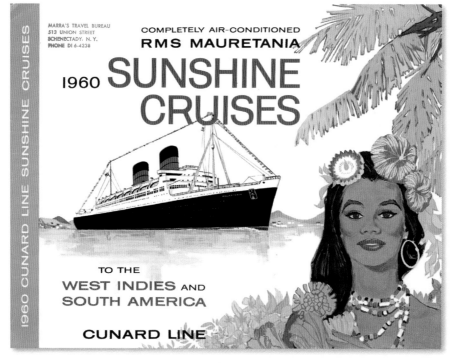

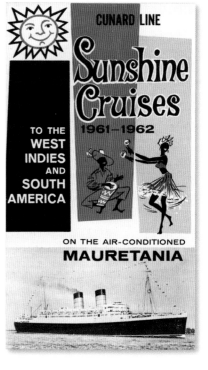

THE MAURETANIA VIA THE *SOUTHERN ROUTE*
TO OR FROM THE MEDITERRANEAN

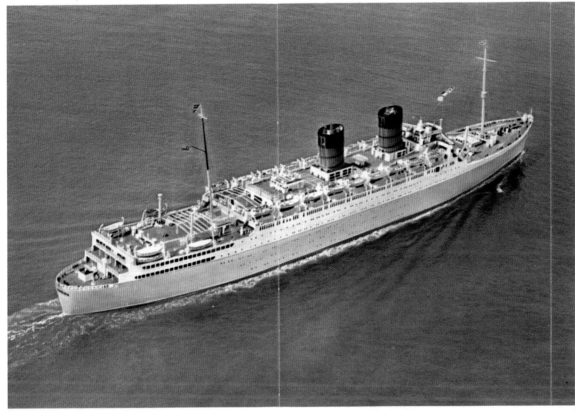

Better bring along your bathing suit!

And a blithe spirit, of course. The merry Mauretania has been the happy choice of thousands of cruise passengers who have succumbed to her charms on cruises through the West Indies and the Mediterranean. She's the largest liner in Mediterranean service—35,655 tons of stability; her speed is the pride of her crew; she's fully air-conditioned.

Towering a magnificent ten decks, the pale green Mauretania has two swimming pools, numerous lounges, cocktail bars and smoking rooms, a terraced Lido Deck, three delightful restaurants, three children's playrooms, a comfortable theater, elegant shops, several beauty parlors and barber shops, a well-stocked library—every service to keep you ship-shape and to add to the pleasure of your voyage.

And look at the other bonuses you get with a Cunard ticket! Four cruise ports—You can disembark at Gibraltar, Cannes, Genoa and Naples. You may return to New York from any of these ports if you wish, or from England or France in any of seven other Cunarders. All this plus Cunard's *"Getting There is Half the Fun!"* ingredient.

NOW YOU CAN SAIL **CUNARD** *TO:*
GIBRALTAR GENOA
CANNES NAPLES

⌃ Announcement details of the southern route from New York to the Mediterranean, 1963.

1963 Mauretania Mediterranean Cruise

Sailing From New York
February 5, 1963

The air-conditioned **MAURETANIA**

❮ Front cover of the 1963 pamphlet of the southern route from New York to the Mediterranean.

❯ Interior details from the 1963 pamphlet.

This is your ship—the luxury cruise liner
MAURETANIA

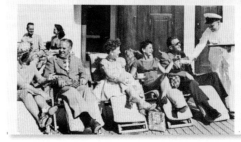

...and it's the wisest choice you could have made because even before you arrive at your first port you'll see why she is such a popular cruise ship. Once aboard, this fabulous floating resort becomes your home — elegantly decorated, efficiently run and graciously staffed.

The Mauretania is perfect for a Mediterranean cruise...she is a speedy 35,000 ton air-conditioned luxury ocean liner. She has ten passenger decks, two swimming pools and acres of open deck space for sunning and strolling. Her many lounges, cocktail bars and smoking rooms are convenient, congenial places to meet friends.

She has a terraced Lido Deck...cool, comfortable staterooms...and exquisite restaurants, where you'll savor many a memorable meal. You'll see first-run movies in the cinema, attend parties and balls in the large public rooms or just wile away hours relaxing on deck. Each last detail is carefully cared for by a courteous, efficient staff... proud to serve your slightest whim.

Remember...Cunard caters to your comfort and fills superbly our promise of leisure and luxury at its best.

Front cover of the pamphlet from the cruise to Israel, 1963.

TWO PERSONALLY CONDUCTED TOURS

to ISRAEL

FOR PASSOVER & SHAVUOTH
MARCH 28, 1963 MAY 15, 1963

SS FRANCE

Sail on The R.M.S. MAURETANIA via the Mediterranean
Return on THE NEW S.S. FRANCE

GATEWAY CARAVEL TOURS

List of Passengers

CUNARD LINE

FIRST CLASS RATES
TO OR FROM BRITISH AND IRISH PORTS · **R.M.S. MAURETANIA**

▶▶▶ RATES TO OR FROM FRENCH PORTS — ADD $10. PER ADULT AND $5. FOR CHILDREN 1 YEAR AND UNDER 12. ◀◀◀

	Bed Rate	Room Alone
SUN DECK		
Outside Rooms with Bath		
With bed and upper berth — S. 11, 15, 25, 27, 29	$355.	$444.
Outside Rooms with Shower and Toilet		
With two beds — S. 4, 6, 17, 19, 20, 21, 22	380.	570.
With bed and upper berth — S. 3, 5, 7, 8, 10, 12, 14, 16, 23	345.	432.
Single bedroom — S. 9, 18, 31, 33	—	425.

	Suite for 1	Suite for 2
MAIN DECK		
Suites		
With bedroom (2 beds), sitting room and 2 baths — M. 39 & 41, 40 & 42, 43 & 45, 44 & 46	1733.	1980.

	Bed Rate	Room Alone
Outside Rooms with Bath	495.	743.
With two beds — M. 39, 40, 41, 42, 43, 44, 45, 46		
With two beds — M. 33, 34, 35, 36, 37, 38, 47, 48, 49, 50, 51, 52, 53, 54, 55, 56, 57, 58, 59, 60, 61, 62, 63, 64, 65, 66, 67, 68, 69, 70, 71, 72, 73, 74, 81, 84	470.	705.
	445.	668.
With two beds and upper berth M. 31, 32, 87, 90, 93, 96, 99, 102	445.	668.
With two beds — M. 11, 14, 17, 18, 23, 24, 27, 28, 83, 86, 89, 92, 95, 98, 108	365.	457.
With bed and upper berth — M. 7, 10	—	425.
Single bedroom — M. 3, 4		
Outside Rooms with Shower and Toilet		
With two beds and upper berth — M. 29, 30	380.	570.
With two beds — M. 103, 104	380.	570.
Outside Rooms		
With bed and upper berth — M. 2	335.	419.
Single bedroom — M. 101	—	375.
Inside Rooms with Bath		
With bed and upper berth — M. 82	345.	432.
Inside Rooms with Shower and Toilet		
With bed and upper berth — M. 19, 20, 75, 79	335.	419.
Single bedroom — M. 85, 88, 91, 94, 97, 100, 106	—	360.
Inside Rooms		
With bed and upper berth — M. 1, 5, 8, 15, 16, 25, 26	325.	407.
Single bedroom — M. 6, 9, 12, 21, 22	—	325.

	, 47, 48, 49, 50, 51, ... 0, 61, 62, 63, 64, 65 ... 23	Bed Rate	Room Alone
		455.	683.
		455.	683.
		415.	623.
		415.	623.
		390.	585.
		390.	585.
		345.	518.
		335.	419.
		—	375.
		—	375.
		335.	419.
		335.	419.
		—	335.
	87, 90, 91, 94, 95	325.	407.

...e the sale of a room for less than capacity.
...s. All rates are subject to change without notice.

▲ *Mauretania* first-class passenger rates.

◀ *Mauretania* first-class passenger list front cover for the New York–Southampton service in 1950.

⌄ *Mauretania* revue programme front cover, 1961.

R.M.S. "MAURETANIA"

EMPIRE STATE MASON CRUISE

Captain J. CROSBIE DAWSON, D.S.C., R.D., R.N.R.

MAURETANIA VARIETIES

★

in the Grand Hall
on MONDAY, JANUARY 16th, 1961
at 9.00 and 10.30 p.m.

★

Introduced by
Master of Ceremonies RONNIE MORTON
 ROCK MORTON

Programme

Overture	...		RAY GORDON AND HIS ORCHESTRA
Tops In Taps	EDDIE LAWRENCE Cafes - Hotels
Instrumentalists		...	JOE RANKIN & JEAN European Clubs - Theatres
Impressions ...			ROCK MORTON European Tours Presentation Theatres
Prestidigitator		...	RICO Theatres - Night Clubs
Comedian	WHITEY ROBERTS Television - Night Clubs
Soprano	...		ELAINE MALBIN Television - Opera

Conductor - JACK ROTH

Artists under the direction of
EPH ABRAMSON
1440 Broadway New York
Music by
GERALDO OF LONDON

⌃ *Mauretania* revue programme interior.

R.M.S. "MAURETANIA"
HAIRDRESSING DEPARTMENT

C DECK MAIN DECK

Name.......*MS Reilliei*........

Cabin No..........*B68*.......
 We respectfully wish to remind you that your appointment
is for :-
Date.........*May 9ᵗʰ Sunday*.......
Time*6*....~~a.m.~~ p.m.
Operator.......*M— Auld*.......

COSMETICS ON SALE : PERFUMES : TOILET REQUISITES

FIRST CLASS. AFT.

SINGLE SITTING.

Table No.......*54*.......

Seat No..............

Name..............

Passengers are requested to hand this card to the table
Steward when taking their seat at first meal.
39/9027

Mauretania hairdressing and table
reservation cards.

T 54 a/t

TABLE RESERVATION

Mr & Mr N. Davis

B. 112

THE CUNARD STEAM-SHIP COMPANY LIMITED
FOR PASSAGE TICKET

Passengers are requested to read carefully the conditions both on the front and back of the enclosed contract of transportation.

Cruise .. *Class Passage*

Per S.S. Mauretania ...

Sailing from New York Pier No 90./92. N.R.

Passengers embark April 4th19 60.

Beginning at 8:00 A M to 10:30 AM

When Daylight Saving Time is in effect, sailing and embarkation hours are shown in Daylight Saving Time.

ADMISSION OF VISITORS
Admission of visitors to the ship will be stopped one hour prior to the end of the scheduled embarkation period indicated above.

Necessary Travel Documents
PASSPORTS—Expiration dates should be carefully checked and passports renewed if necessary, as passengers will not be permitted to sail without a valid passport. Your passport must be available for inspection with your ticket, at embarkation.

VISAS—All passengers must secure visas, when required, of all countries which they intend to visit except the country of which they are citizens or subjects.

SAILING PERMITS—Before departure from the United States, all passengers, except U.S. Citizens, and those in transit through the United States within five days, must secure a Sailing Permit (Income Tax Clearance Certificate) from the U.S. Dept. of Internal Revenue in their local district. In New York, Sailing Permits are issued at 484 Lexington Ave. (Grand Central Palace Building, between 46th and 47th Streets).

RE-ENTRY TO THE U.S. OF RESIDENT ALIENS—Resident Aliens returning within one year will only require their Alien Identification Card (U.S. Form I-151). Those remaining abroad longer will require an unexpired re-entry permit or a non-quota visa.

Vaccination
All persons entering the Port of New York must have valid vaccination certificates which indicate that the vaccination was successful or showed immunity. See a copy of the Company's sailing list or consult your local agent.

Westbound Embarkation Arrangements
In order to obtain complete and accurate embarkation information for sailings from:-
Cherbourg and Havre—passengers should confirm their reservations at the Cunard Line Office, 6 Rue Scribe, Paris.
British and Irish Ports—passengers should confirm their reservations at any of the Company's offices in the U.K. or Ireland.
Tipping or Gratuities to Porters at the Entrance to or on the Company's Piers, is not Required.

SEE OVER

Mrs. M. FitzGerald

⌃ Passenger ticket for the *Mauretania*, 4 April 1960.

❯ *Mauretania* memo regarding a press conference with the President of Turkey.

News
from **Cunard White Star**

Cunard White Star Limited • 25 Broadway, New York 4, N. Y. • TEL. BO 9-5300

FOR IMMEDIATE RELEASE OCTOBER 12, 1949

EUROPE-BOUND STOWAWAY WINDS UP IN JAIL, FINDS STOWING AWAY IS MORE DIFFICULT THAN IT SEEMS

In the bygone era of square-rigged sailing ships and Barbary pirates, ocean-going stowaways in search of adventure discovered instead the gruelling monotony of swabbing decks and polishing pots while the ship shuttled endlessly from outport to outport. Present day stowaways may be spared the tedium of twenty-nine trying months at labor in a seething cargo hulk, but the illicit search for adventure is as vain and disappointing as ever.

John Hoffman, of 112 East 98th Street, New York, who stowed away aboard the Mauretania at her Hudson River pier last month with visions of a free trip to Europe on a luxury liner, would be the last man in the world to dispute this observation. Apprehended shortly after sailing time, he was taken into custody on arrival at Southampton, and instead of experiencing the adventure of foreign travel, Mr. Hoffman is currently serving a one month prison term, imposed by local magistrates, prior to deportation, which will bring him -- of course -- right back to New York.

⌃ *Mauretania* press release regarding a stowaway, 12 October 1949.

Form A.180

The Cunard Steam-Ship Company Limited
MEMORANDUM

From The Purser, To The Staff Captain,

Ship R.M.S. "Mauretania"

G34/332 25th. January, 19 54.

DECODE OF CABLE RECEIVED 2144 HOURS 25th. JANUARY, 1954.

Two cutters with approximately 150 officials and Press boarding you at Quarantine request First Class Smoking Room for Turkish President and other interviews and Verandah Cafe for Press refreshments also electricians available.

> *Mauretania* press release regarding the American tour of Manchester City Football Club, 13 May 1958.

News from Cunard

THE CUNARD STEAM-SHIP COMPANY LIMITED • Telephone BO 9-5300 • 25 Broadway, New York 4, N.Y.

May 13, 1958

FOR IMMEDIATE RELEASE:

MANCHESTER CITY FOOTBALL CLUB DUE THURSDAY IN CUNARDER MAURETANIA

 The 20-member Manchester City Football Club, led by their manager L.S. MCDOWALL (A-101), is among 508 passengers arriving in New York, Thursday, May 15 in the 35,674 - ton Cunard liner Mauretania from Cobh, Havre and Southampton. The team is arriving to undertake a summer playing tour of the United States and Canada.

 Commanded by Captain J.D. Armstrong, the ship is ~~~~~ at Pier 90, West 50th Street.

~~ STAMP W. WORTLEY ~~ in Great Britain ~~ dent of the Chase

⌄ Boxing contest announcement aboard the *Mauretania*.

MAURETANIA SOCIAL AND ATHLETIC CLUB

BOXING CONTEST

(By kind permission of Captain J. W. CAUNCE
R.D., R.N.R.

At 3.00 p.m., TODAY, On the Sun Island

BLUE	BANTAM-WEIGHT	RED
DAVE MACDONALD	V	MARTIN CLARKE
112 lbs.		114 lbs.

BLUE	FEATHER-WEIGHT	RED
DAVE BOYLE	V	TOMMY ROBERTS
(135 lbs.)		(136 lbs.)

BLUE	MIDDLE-WEIGHT	RED
JIM GARRETT V		
ex-Irish A.B.A. Champion (150 lbs.)		
	DAVE WINGROVE	
	Ex-English A.B.A. Champion (150 lbs)	

BLUE	WELTER-WEIGHT	RED
LEO CAPLAN	V	SYD HUMPHRIES
(145 lbs)		(143 lbs)

BLUE	LIGHT HEAVY-WEIGHT	RED
JACKIE McCLELLAN	V	MAX HALL
(162 lbs.)		(160 lbs.)

Master of Ceremonies :
Staff-Captain P. A. READ, D.S.C., R.D., R.N.R.

Surgeon in attendance :
Dr. P. F. X. O'Neill, M.B., B.Ch., B.A.O., D.R.C.O.G.

Referee :
Mr. Peter Duffy
(Twice International Representative for Ireland)

Timekeeper :
Mr. Burnhope

NEWS FROM CUNARD

THE CUNARD STEAM-SHIP COMPANY LIMITED
25 BROADWAY, NEW YORK 4, N.Y. • BO 9-5300

December 14, 1962

FOR IMMEDIATE RELEASE:

NEW "CRUISING GREEN" MAURETANIA DUE IN NEW YORK TUESDAY FROM SOUTHAMPTON, HAVRE;
RECENT OVERHAUL READIES LINER FOR CHRISTMAS CRUISE, NEW MEDITERRANEAN SERVICE

 Fresh from her annual overhaul, the 35,655-ton Cunard liner Mauretania will make her first arrival in New York in her new "cruising green" hull colors on Tuesday, December 18 from Southampton and Havre.

 Commanded by Captain J. T. Jones, the liner is expected to dock at 6:00 p.m. at Pier 90, West 50th Street.

 The occasion for the Mauretania's new color scheme is her forthcoming entry into regular Mediterranean service on March 20th. Her New York- Naples sunshine route will also include calls at Gibraltar, Cannes and Genoa.

 Prior to the new service, the liner will make an 11-day Christmas Cruise to the West Indies from New York on December 21 and a 41-day, 15-port Mediterranean Cruise from New York on February 5th.

 Among the prominent passengers arriving on Tuesday are HIS EMINENCE JOSE GARIBI CARDINAL RIVERA (M-40), Primate of Mexico; LT. COL. SIR WALTER BROMLEY-DAVENPORT (M-102), Member of Parliament for the Knutsford Division of Cheshire, with Lady Bromley-Davenport; DR. PRESTON BRADLEY (S-19), well known Evangelist, with Mrs. Bradley; and THE MARCHESA MATTEI (A-39).

< Press release regarding the new cruising-green livery and re-routing to the Mediterranean service, 14 December 1962.

West Indies Sunshine Cruise

CRUISE SOUVENIR

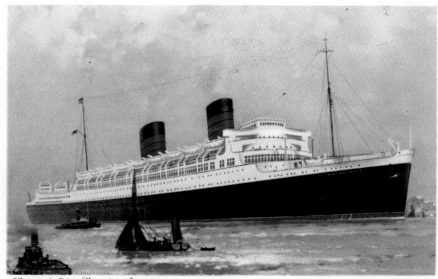

Cunard R.M.S. "Mauretania"

Sailing from New York

TUESDAY, APRIL 7th, 1959
to
SUNDAY, APRIL 19th, 1959

Calling at six ports

ST. THOMAS

MARTINIQUE ★ TRINIDAD

CURACAO ★ PORT-AU-PRINCE ★ NASSAU

❮ A souvenir front cover from the West Indies cruise in April 1959.

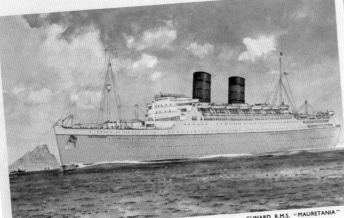

SOUVENIR OF VOYAGE

CUNARD R.M.S. "MAURETANIA"

NASSAU CRUISE

Sailing from New York, 16th November to 21st November, 1963

JULY FOURTH

IN CELEBRATION OF INDEPENDENCE DAY
and the
110TH ANNIVERSARY of the CUNARD LINE

Cunard
1840 • 1950

∧ 'Souvenir of Voyage' from 1963's Nassau cruise.

❯ RMS *Mauretania* Fourth of July celebration menu.

❯ The *Queen Mary* keeps the *Mauretania* company in Ocean Dock, Southampton, on 25 August 1964. (Austen Harrison/World Ship Society)

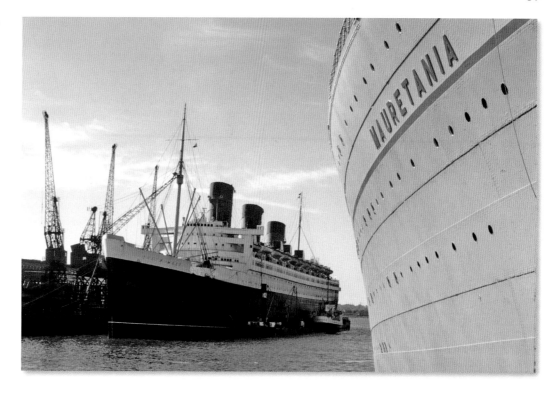

❯ Peering over the roof of a classic car is the outbound French Liner SS *France*, framed in between the *Queen Mary* and *Mauretania* at Ocean Dock, Southampton, on 25 August 1964. (Austen Harrison/World Ship Society)

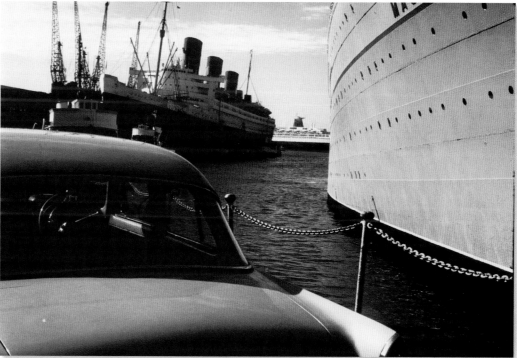

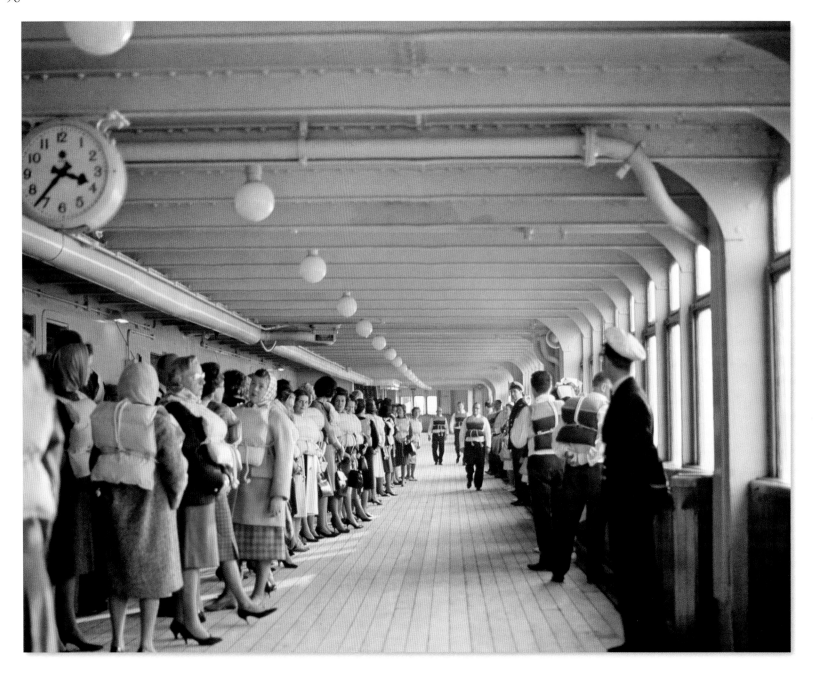

^ Life boat drill on the promenade deck of the *Mauretania* on 27 October 1964. (Valero Energy/Texaco)

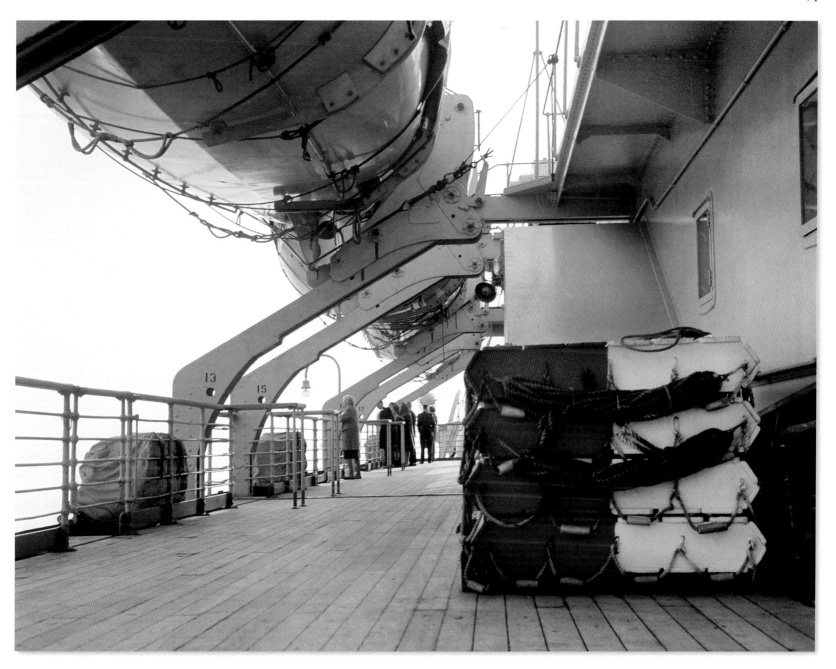

^ Guests line the rails of the *Mauretania* as they sail down Southampton Water on 27 October 1964. (Valero Energy/Texaco)

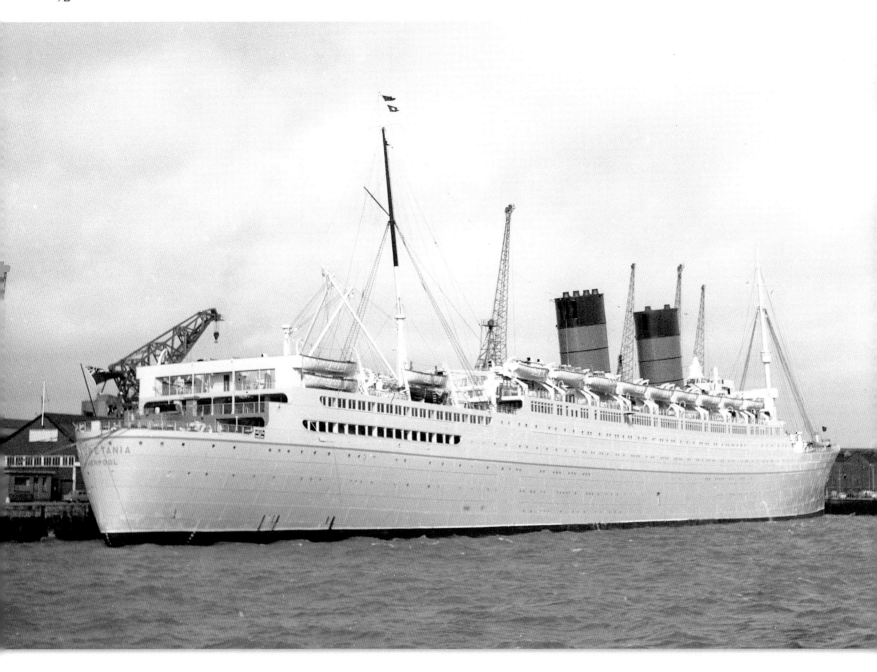

^ This 1965 picture shows the *Mauretania* waiting in Ocean Dock, Southampton, ready for her next cruise to the Mediterranean, under the command of her final master, Captain John Treasure Jones. (World Ship Society)

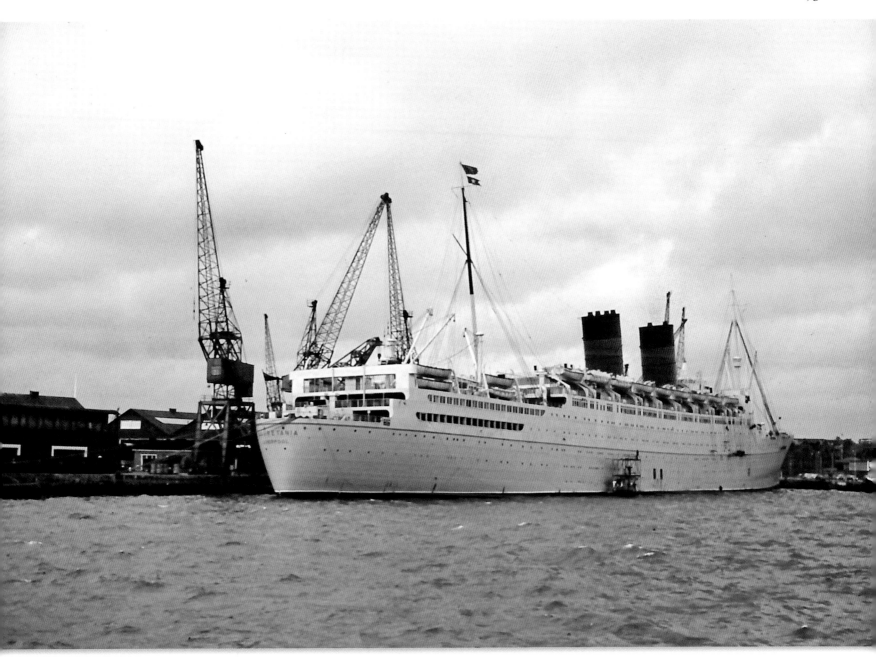

^ Southampton photographer and author Barry Eagles has captured the painters at work on the floating platform at the side of the *Mauretania* in Ocean Dock. (Barry Eagles)

94

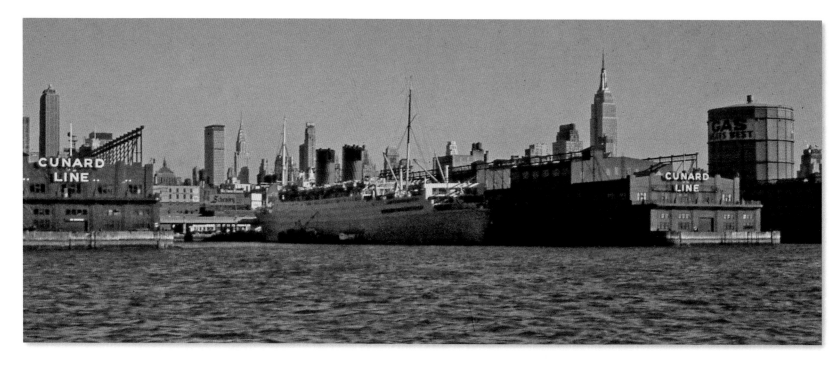

^ Basking in the shadows of Pier 90 at New York, the *Mauretania*, painted in her cruising-green livery, is replenished with Bunker C fuel oil from a Brooklyn 'sea cow' barge. (Britton Collection)

⌄ With the backdrop of Manhattan, the green-liveried *Mauretania* and RMS *Queen Elizabeth* rest side by side at Pier 92 at West 52nd Street in New York. (Britton Collection)

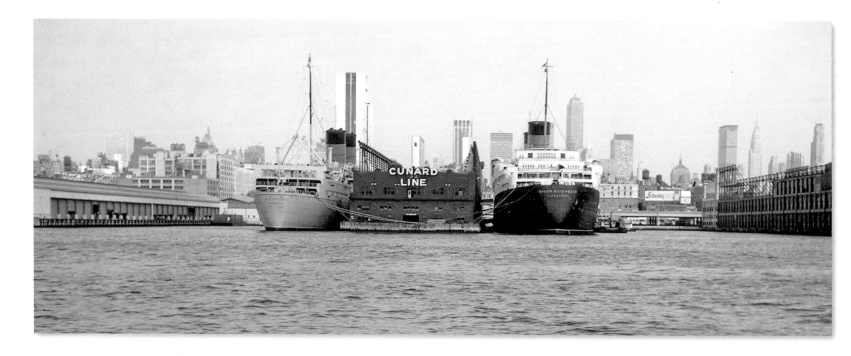

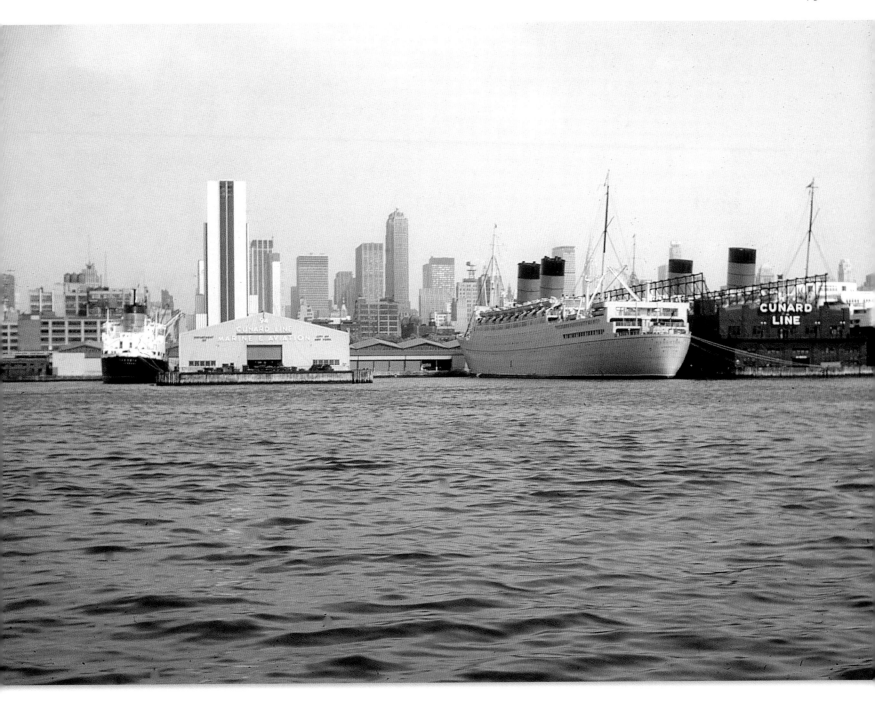

^ On the left of the picture at Cunard Pier 94 in New York is the 13,362-ton *Parthia*, which is seen having arrived from Liverpool. To the right are the *Mauretania* and RMS *Queen Elizabeth* berthed side by side at Pier 92. (Britton Collection)

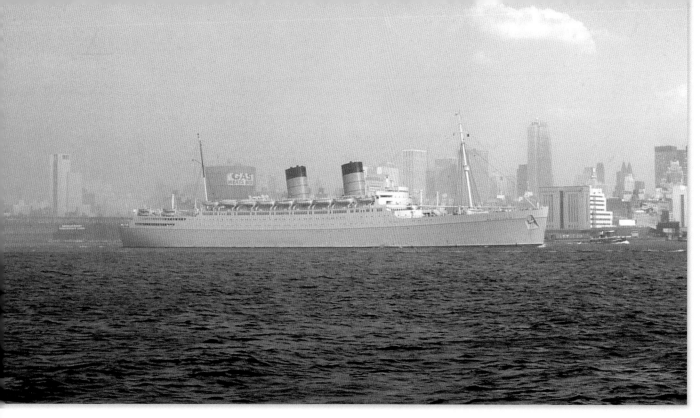

❮ Outbound from New York in October 1964, the *Mauretania* sails slowly down the Hudson, escorted by a lone Moran tugboat. (Britton Collection)

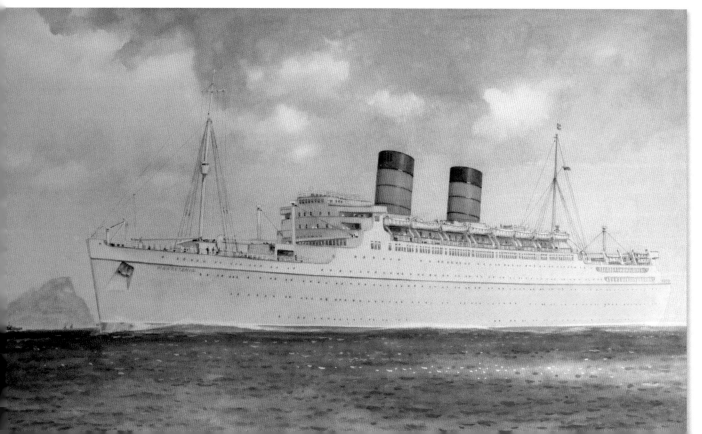

❮ This original watercolour painting was discovered for sale in a second-hand shop in Southampton and was quickly snapped up by the author for a bargain price, using all his pocket money! It was originally used by Cunard for publicity and on a ship postcard. It depicts the *Mauretania* sailing past the Rock of Gibraltar. (Britton Collection)

❯ Passengers are being disembarked from the *Mauretania* via the launches for a visit ashore. The ship has been anchored offshore as there is no suitable deep-water berth during this Mediterranean cruise. (Trevor Smyth)

❯ White-jacketed stewards take a well-earned rest in the fresh air at the stern of the *Mauretania*, whilst sailing though the Mediterranean in 1965. (Trevor Smyth)

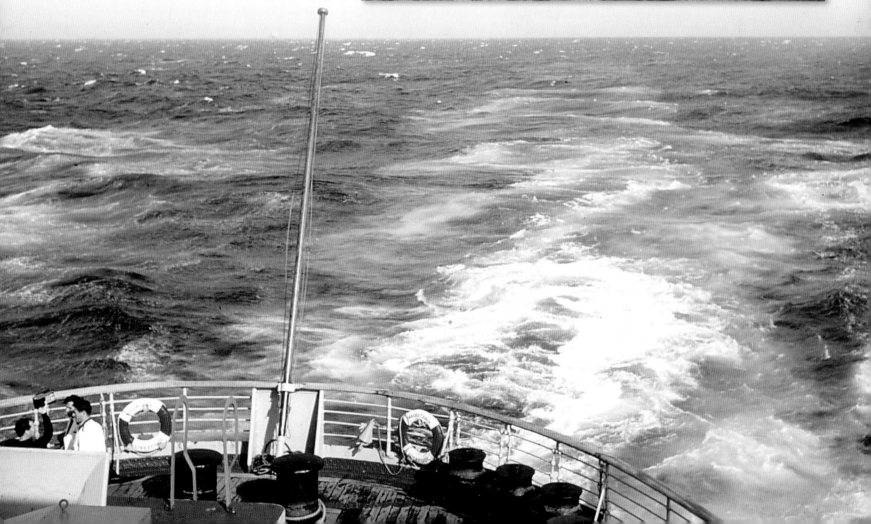

^ This is a view of the sun deck on a Mediterranean cruise with passengers relaxing in the deck chairs, but just look at the attire of the gentlemen: jackets and ties. Fashions have changed dramatically! (Trevor Smyth)

^ Deck quoits on board the *Mauretania*. (Trevor Smyth)

❮ The *Mauretania* stewards line up in preparation for a popular Mediterranean cruise deck buffet at 4 p.m. (Trevor Smyth)

^ Intense concentration watched by cheering passengers during a deck game on the *Mauretania* during a Mediterranean cruise. (Trevor Smyth)

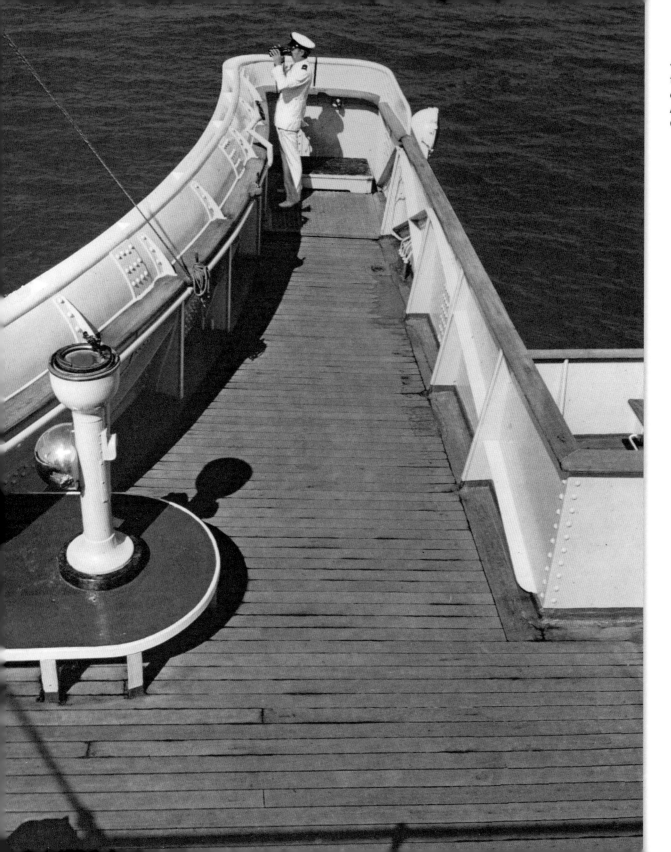

❮ A bridge officer gazes out ahead through his Zeiss 12 x 50 binoculars on the starboard flying bridge of the *Mauretania* in January 1963. (Britton Collection)

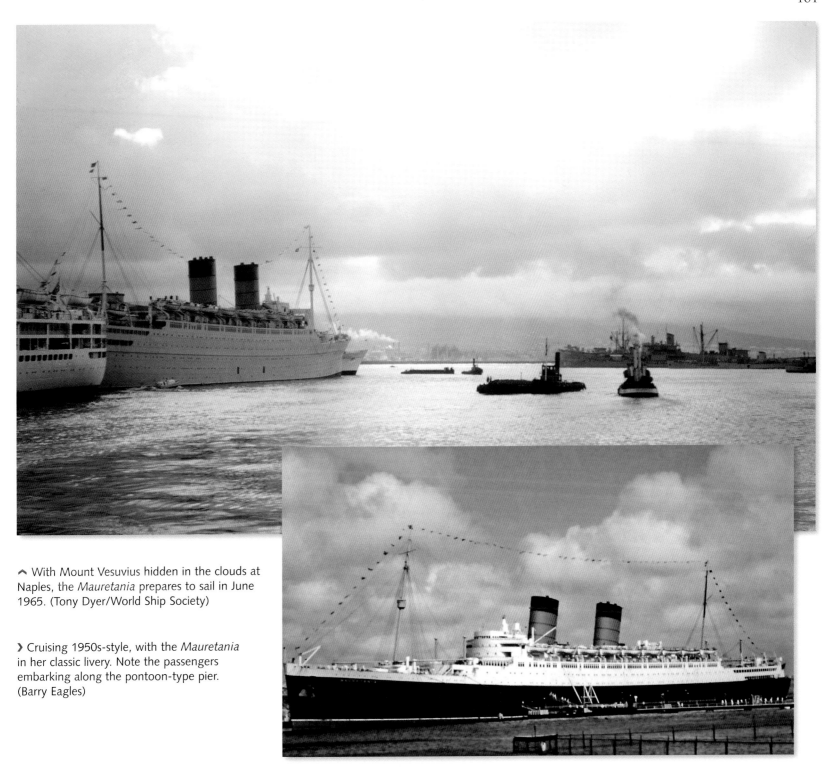

∧ With Mount Vesuvius hidden in the clouds at Naples, the *Mauretania* prepares to sail in June 1965. (Tony Dyer/World Ship Society)

❯ Cruising 1950s-style, with the *Mauretania* in her classic livery. Note the passengers embarking along the pontoon-type pier. (Barry Eagles)

^ The *Mauretania* is pictured framed between the trees from Blackbeard's Castle Hill, Charlotte Amalie, St Thomas, anchored safely beyond a reef on 26 January 1952. (Britton Collection)

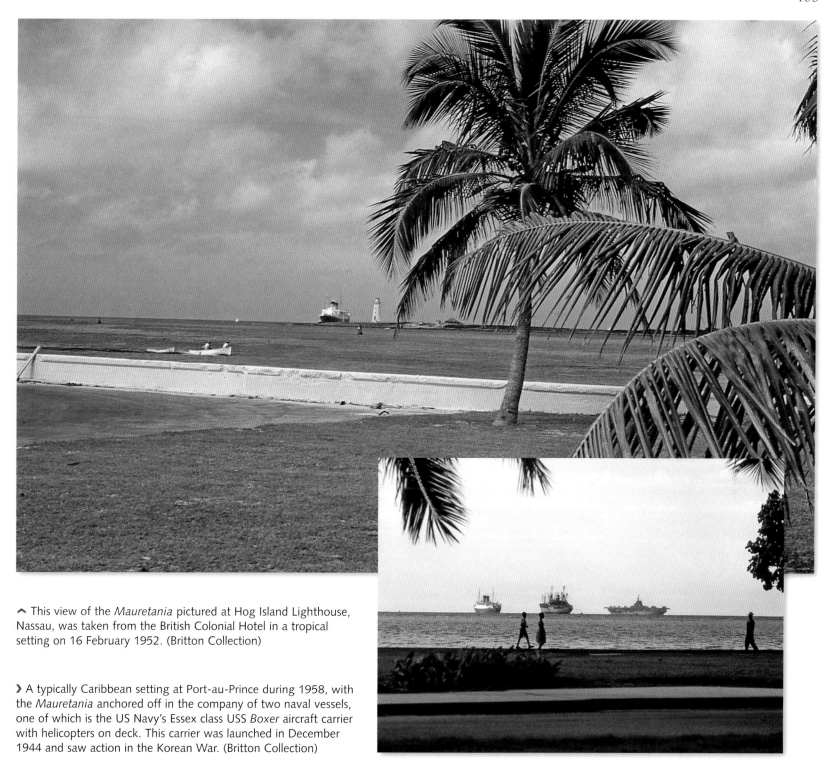

⌃ This view of the *Mauretania* pictured at Hog Island Lighthouse, Nassau, was taken from the British Colonial Hotel in a tropical setting on 16 February 1952. (Britton Collection)

❯ A typically Caribbean setting at Port-au-Prince during 1958, with the *Mauretania* anchored off in the company of two naval vessels, one of which is the US Navy's Essex class USS *Boxer* aircraft carrier with helicopters on deck. This carrier was launched in December 1944 and saw action in the Korean War. (Britton Collection)

❮ Local vendors sell their wares under the bows of SS *Independence*, whilst anchored off out in the bay at Port-au-Prince is the *Mauretania*. (Britton Collection)

❮ Looking over the tropical palm trees at Port-au-Prince out into the bay are the French Line's *Liberté* and Cunard's *Mauretania*. (Britton Collection)

❯ A busy time at the idyllic setting of Port-au-Prince with, from left to right: *Mauretania*, *Nieuw Amersterdam* and *Liberté*. (Britton Collection)

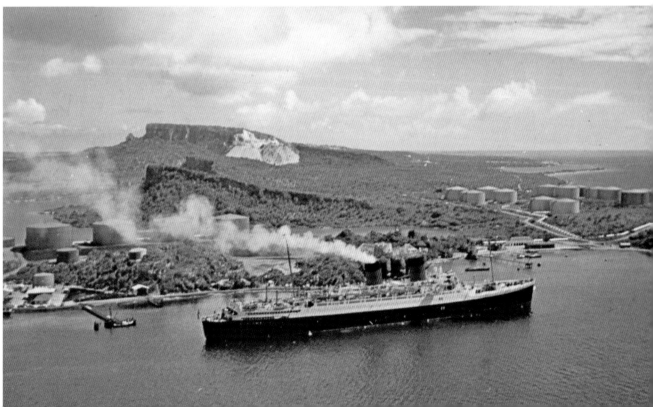

❯ The *Mauretania* is anchored offshore in the port at Caracas Bay, Curaçao. (Britton Collection)

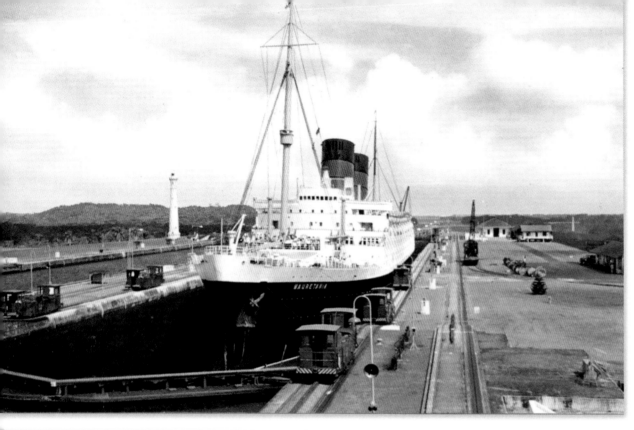

❮ The *Mauretania* is pictured passing through Gatun lock on the Panama Canal. (Britton Collection)

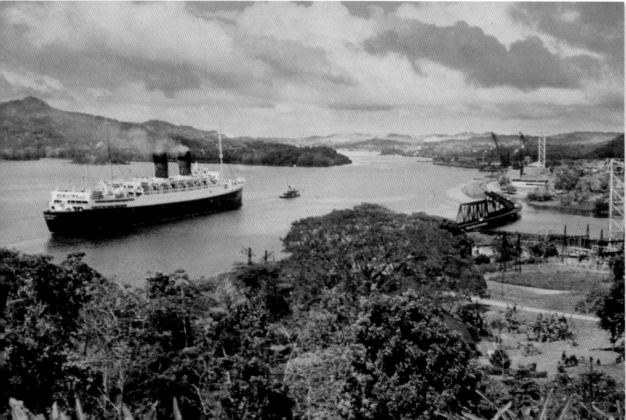

❮ The humidity and insects were said to be almost unbearable as the *Mauretania* passed through the Panama Canal. (Britton Collection)

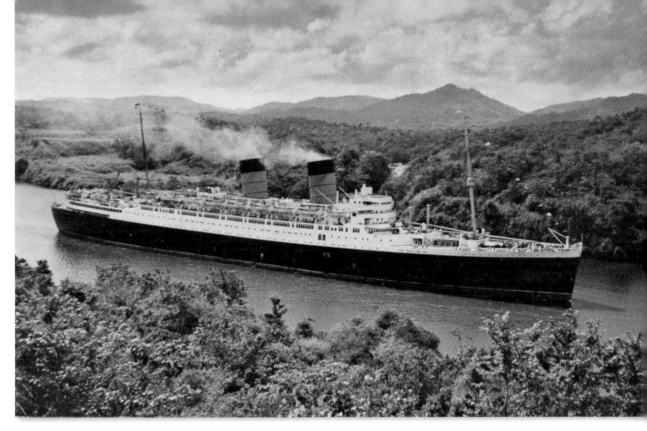

❯ A postcard depicting the *Mauretania* sailing along the Panama Canal. (Britton Collection)

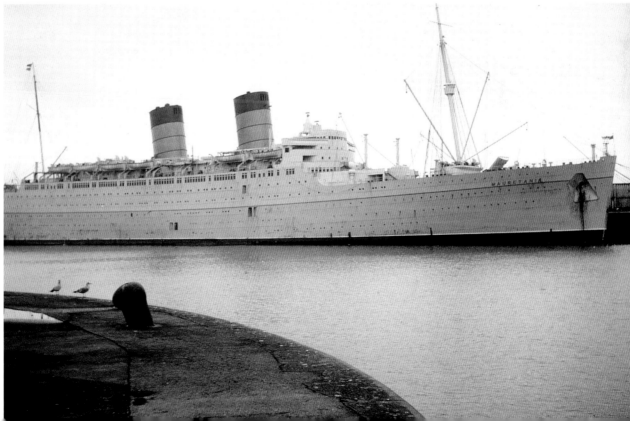

❯ Two seagulls stand on the quayside at Liverpool to peer at the rather rusty-looking *Mauretania* in January 1965. (Bert Novelli/World Ship Society)

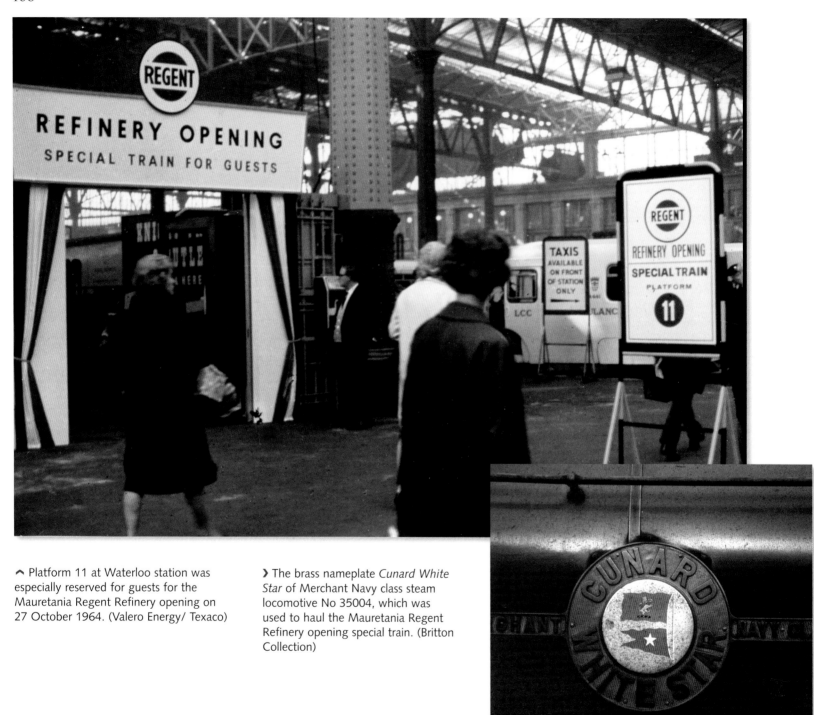

^ Platform 11 at Waterloo station was especially reserved for guests for the Mauretania Regent Refinery opening on 27 October 1964. (Valero Energy/ Texaco)

❯ The brass nameplate *Cunard White Star* of Merchant Navy class steam locomotive No 35004, which was used to haul the Mauretania Regent Refinery opening special train. (Britton Collection)

^ Captain John Treasure Jones can be seen on the bridge of the *Mauretania*. The brass oval-shaped plate just above the passengers' heads is the Cammell Laird builder's plate. (Valero Energy/Texaco)

^ A life ring on the deck railings with the legendary words 'Mauretania Liverpool'. (Valero Energy/Texaco)

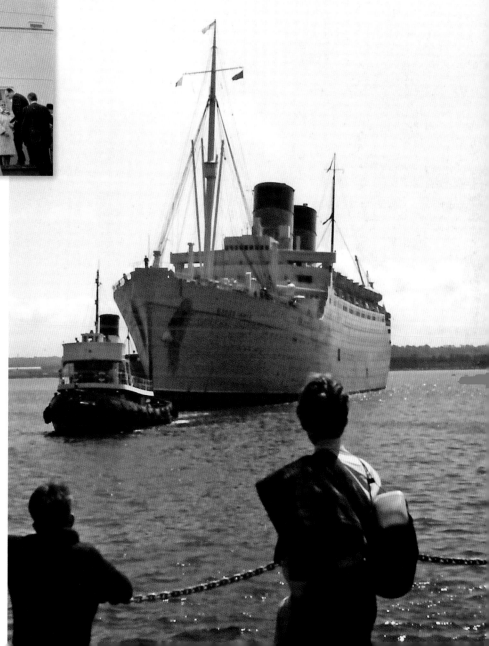

˅ Spectators watch in awe and wonder as the *Mauretania* departs from Ocean Dock, Southampton, assisted by Alexandra Towing Co. and Red Funnel tugs on 27 October 1964. (Barry Eagles)

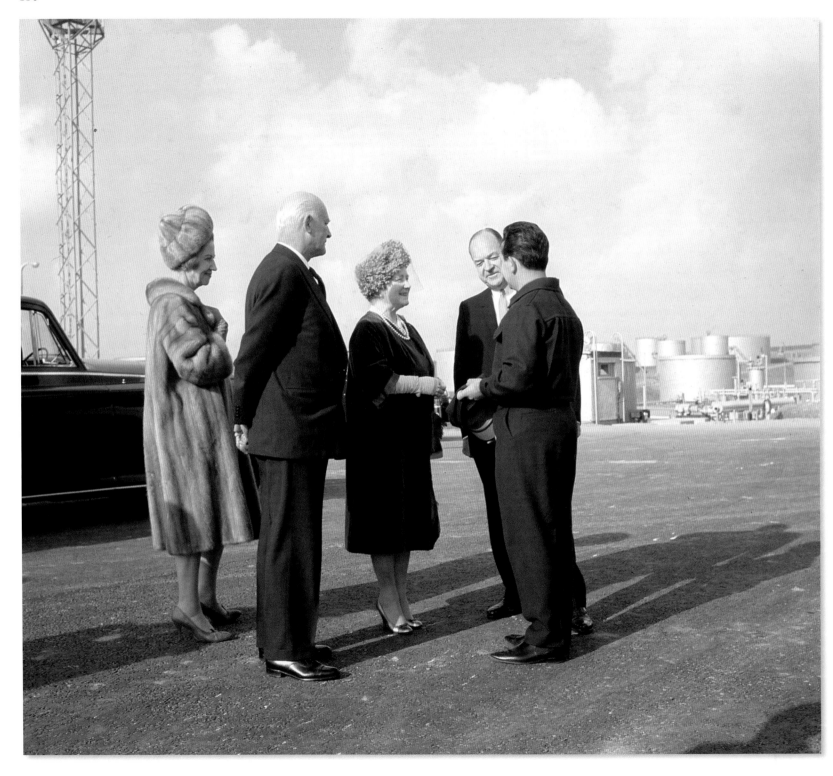

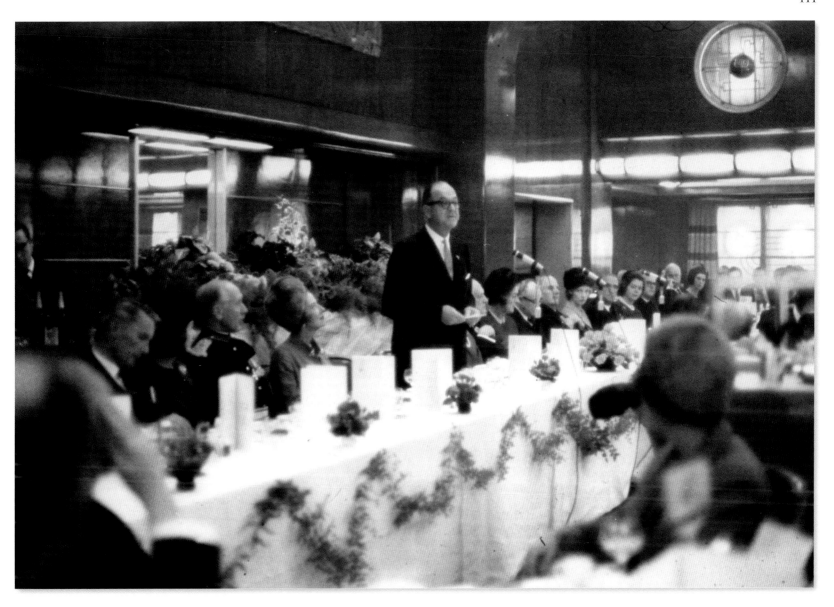

❮ Sir Edward Beetham, the chairman of Regent Petroleum, and his wife present Her Majesty Queen Elizabeth the Queen Mother, arriving to open the Milford Haven Refinery on 27 October 1964. (Valero Energy/Texaco)

⌃ Sir Edward Beetham welcomes Her Majesty Queen Elizabeth the Queen Mother on board the *Mauretania* for a meal. This was a very proud moment for the ship in her twilight years. (Valero Energy/Texaco)

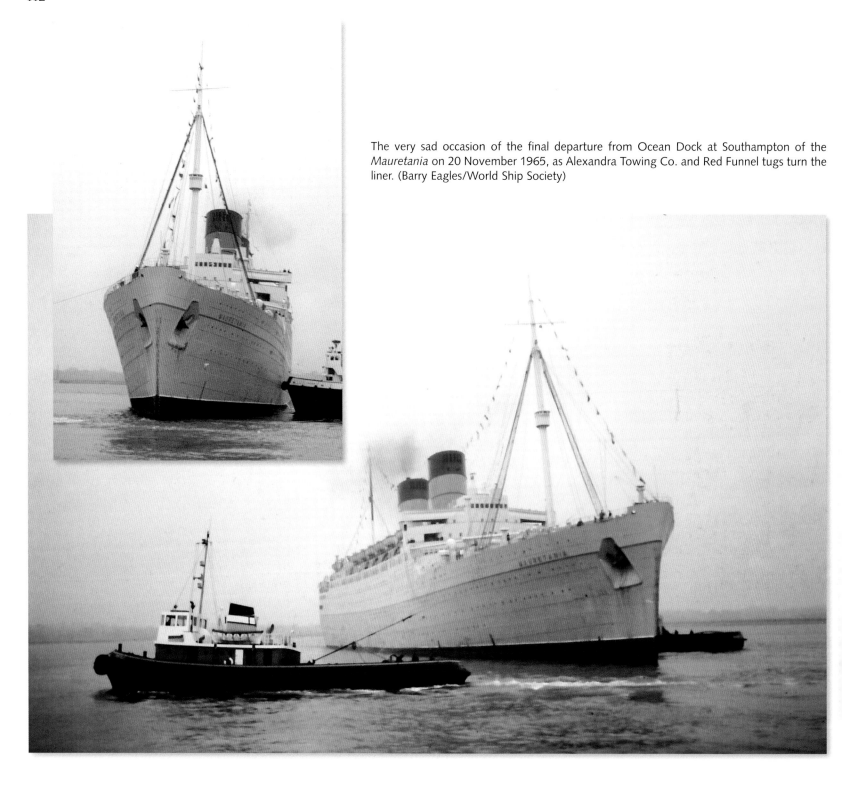

The very sad occasion of the final departure from Ocean Dock at Southampton of the *Mauretania* on 20 November 1965, as Alexandra Towing Co. and Red Funnel tugs turn the liner. (Barry Eagles/World Ship Society)

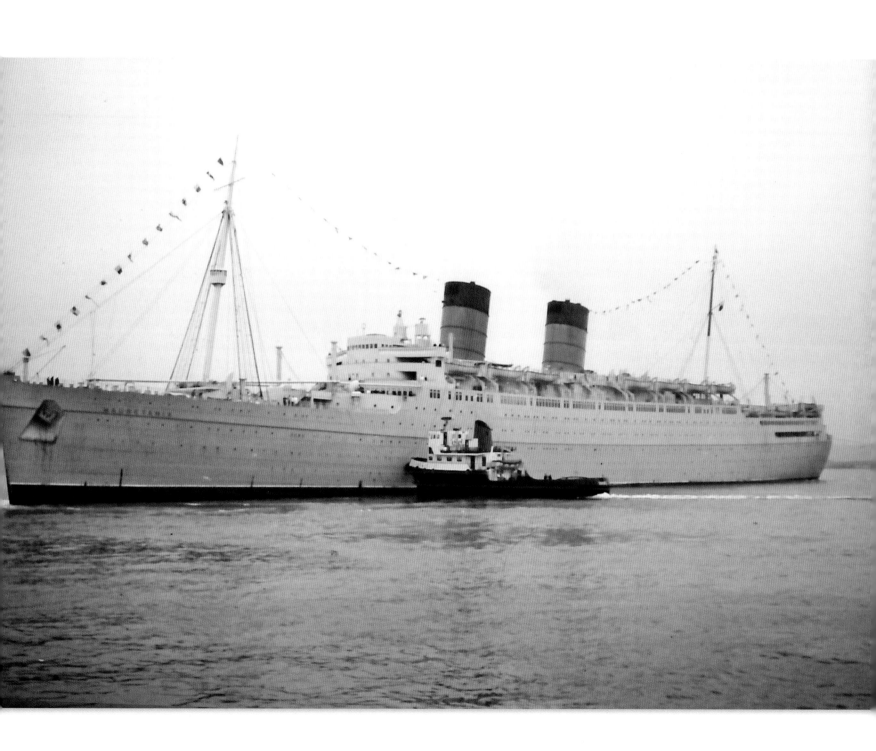

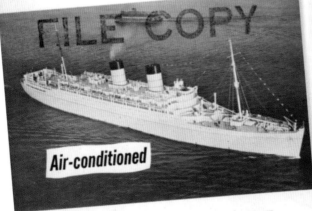

CUNARD LINE

SPECIAL VOYAGE FROM

LISBON

DIRECT TO

NEW YORK

ABOARD THE FAMOUS CRUISE LINER

MAURETANIA

35,655 gross tons

Air-conditioned

Sailing Sept. 6, 1965

❮ Front cover of the pamphlet for the special voyage from Lisbon to New York, September 1965.

❮ The final *Mauretania* Mediterranean cruise, souvenir front cover.

All Mediterranean Cruise

Souvenir of Voyage

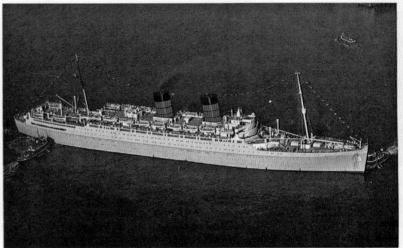

CUNARD R.M.S. "MAURETANIA"

WEDNESDAY, 15th SEPTEMBER to WEDNESDAY, 10th NOVEMBER, 1965

MADEIRA - CASABLANCA - GIBRALTAR - TANGIER
CAGLIARI - PALERMO - MALTA

ALEXANDRIA - BEIRUT - HAIFA - RHODES
DARDANELLES - ISTANBUL - ATHENS

MYKONOS - DELOS - HERAKLEION - DUBROVNIK
TRIESTE - VENICE - SYRACUSE

MESSINA - NAPLES - AJACCIO - VILLEFRANCHE
BARCELONA - PALMA - MOTRIL

MALAGA - LISBON - CHERBOURG - SOUTHAMPTON

Cunard Cruise News

ALL MEDITERRANEAN CRUISE

On Board R.M.S. "MAURETANIA" Wednesday, 15th September, 1965

Welcome Aboard

The Captain and members of the Ship's Company, the Cruise Director and his Staff bid you a cordial welcome. For the many who make a Cunard cruise an annual event as well as for those who have never before participated in the carefree joys of cruising, we want this cruise to be a most delightful experience.

The variety of shipboard entertainment — the Gala Balls, the motion pictures, the cabaret shows, the gymkhanas and the numerous other activities, along with the shore excursions at the fascinating ports, have been carefully planned for your maximum pleasure. The meals, the service, the deck luncheons and the midnight buffets have been arranged for the most discriminating taste.

One hundred and twenty-five years of seamanship and Cunard tradition stand behind the running of the MAURETANIA and it is our sincere desire that she fulfils her role as your comfortable and happy home afloat. We are proud of our ship and it is our wish that you will be as fond of her as we are.

HAPPY CRUISING !

^ The final *Mauretania* Mediterranean cruise, 'Welcome Aboard' details for passengers.

❯ List of officers for the final *Mauretania* Mediterranean cruise.

Cunard Cruise News

LIST OF OFFICERS

Captain : J. TREASURE JONES, R.D., R.N.R. RTD.
Staff Captain : G. E. SMITH

Chief Engineer:
S. E. STOCKHAM

Staff Chief Engineer:
M. DONALDSON

Principal Medical Officer:
W. P. CUTHBERT
M.A., M.B., CH.B.

Surgeon :
F. LOUIS
F.R.C.S., M.B., B.S.

Chief Radio Officer:
E. H. AMBLER
D.S.C.

Chief Officer:
A. BULL

Purser:
H. L. STEVENS

Staff Purser:
W. D. ROUSE

Chief Steward:
J. E. SAWYER

Second Steward:
R. MORRISON

CRUISE OFFICIALS

Cruise Director : Mr. VAUGHN T. RICKARD
Deputy Cruise Director : Mr. JOHN N. TIMKO

Social Directresses:
Miss LORNA YOST
Miss RUTH HARRIS

Cruise Staff:
Mr. J. FERGUSON
Mr. J. MATTE
Mr. D. NEAL
Mr. R. O'NEILL
Mr. R. A. WILLIAMS

Artistes :
ROBERT CANNON
VIVIEN MILAN
ROBERT BURGESS
DOREEN FREEMAN

Shore Excursion Manager:
Mr. JAMES LORAH

Cruise Lecturer :
Mr. ROBERT KUHLMAN

Shore Excursion Staff:
Mr. J. T. COSTELLO
Mr. R. LETTERMAN
Mr. R. A. MAZIK
Mr. W. R. MONTANO
Mr. J. STUART
Mr. N. SYKES
Mr. A. C. VAN HOOREN

Roman Catholic Chaplain:
Rev. Father A. C. ROACH

The ship's officers may be identified by the following insignia:—
Captain, four gold stripes; Staff Captain, four gold stripes; Chief Officer, three gold stripes; Chief Engineer, four gold stripes, purple between; Staff Chief Engineer, four gold stripes, purple between; Principal Medical Officer, three gold stripes, red between; Surgeon, three gold stripes, red between; Purser, three gold stripes, white between; Staff Purser, two-and-a-half gold stripes, white between; Chief Radio Officer, two-and-a-half gold stripes, green between; Chief Steward, three gold zig-zag Stripes, Second Steward, two-and-a-half gold zig-zag stripes.

R.M.S. " MAURETANIA "

All Mediterranean Cruise

Captain J. TREASURE, JONES, R.D., R.N.R. Rtd.

VAUGHN T. RICKARD, Cruise Director

CONCERT

❖❖❖❖❖❖❖

featuring

VIVIEN MILAN, Soprano

ROBERT CANNON, Tenor

with

REG MOORE

and the Mauretania Concert Orchestra

❖❖❖❖❖❖❖

GRAND HA

Sunday, 19th Septem

at 9.30 p.m.

RECITAL

" Rondalla Aragonesa " *Granados*

—o—

" Slavonic Dance No. 3 in A flat Major " *Dvorak*

—o—

(Miss Milan—Mr. Cannon)

1. " Falling in Love with Love "

2. " Mon Coeur S'ouvre a ta Voix " *Saint-Saens*
 from " Samson et Dalila "

3. " Lucevan le Stelle " from " Tosca " *Puccini*

4. " Show Boat "
 (a) Why Do I Love You
 (b) Make Believe
 (c) You Are Love

—o—

" Serenade " *Schubert*

—o—

" Casse Noisette " Suite *Tchaikowsky*
 (a) March
 (b) Sugar Plum
 (c) Danse Arabe
 (d) Danse Trepak

❮ Details of a concert on the final cruise, 19 September 1965.

⌄ The 'Fiesta Andaluza' exhibition of Spanish dancing on the final Mediterranean cruise.

R.M.S. "Mauretania All Mediterranean Cruise

"Fiesta Andaluza"

in the

GRAND HALL

Wednesday, 3rd November, 1965

at 9.30 p.m.

The magic of Spanish Dancing lies in the diversity of its origin; the warmth and charm of the pretty girls of Spain; their spirited emotional grace and picturesque costumes.

The origin dates back from the Moors who ruled Spain and, longest of all, Andalusia for many centuries, to the colourful temperamental gypsies swarming the Andalusian countryside, and reflect the bright, gay, carefree and devil-may-care atmosphere of this ancient country.

But now look for yourself. The castanettes, the guitars and the local band will start to play their fascinating tunes for you. The girls will sway away their flounces and their little agile feet will beat out the spirited rhythms of "Malaguenas," "Sevillanas," "Fandanguillos," "Boleros" and other famous dances of their country.

"OLE"

An Exhibition of Spanish Dancing

by the

MALAGA DANCERS

PROGRAMME

1. DANCES OF HUELVA
 Huelva Canta Ballet Gibralfaro

2. CADIZ CADIZ
 Gaditana Gaditana (Alegrias) Lucy Montes

3. GYPSY RUMBA
 Tienes la cara gitana (Rumba gitana) Ana de Cordoba

4. DANCE OF THE SMUGGLER
 Solera Andaluza Rocio de Triana

5. SEVILLANAS DANCES
 Sevillanas Ballet Andaluz

6. DANCE FROM RONDA
 Soleares de Ronda Piti Halminton

7. FLAMENCO DANCE
 Tanguillo Flamenco Gloria Rosas

8. FLAMENCO RUMBA
 Rumba Flamenco Pepa Vargas

9. DARK HAIR
 Tienes el pelo negro (Seguiriyas) Maripepa Reyes

10. MALAGA DANCES
 Malaga tiene una copla (Malaguenas) Cuadro Final

Cantaor: **Gabriel Campos**

Guitarristas: **Antonio Almera y Sebastian Montiel**

Director Artistico: **Juan Llamas**

R.M.S. "MAURETANIA" All Mediterranean Cruise, 1965

Captain J. TREASURE JONES, R.D., R.N.R. Rtd.
VAUGHN T. RICKARD, Cruise Director

VALETE "MAURETANIA"

Mighty were your engines,

As down the slips you came,

Unfolding to the world once more

Respect for a famous name.

Eager were you then, my friend,

To search the oceans blue,

Aroused by legends of the lands

Now well known to you.

In glory then we bid farewell,

Adieu, great ship, adieu.

GENERAL INFORMATION

Built	10th June, 1939
Builders	Cammell Laird & Co.
Official Number	166,267
Port of Registry	Liverpool
Length—Overall	771ft., 5¾ ins. (235 Metres)
Length	732 ft.
Gross Tonnage	35,655.26
Net Tonnage	19,451.75
Moulded Breadth	89.1 ft. (27 Metres)
Moulded Depth to "C" Deck	38.6 ft.
Stem to Bridge	224 ft.
Stern to Bridge	548 ft.
Loaded Draft, Winter and Summer	30 ft., 11 ins.
Signal Letters	G.T.T.M.
Weight of Anchors	9 tons, 3¼ cwts. each

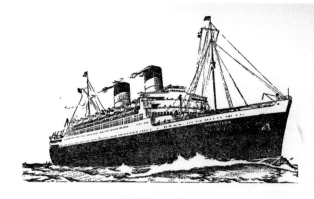

(1939 - 1965)

GALA FAREWELL BALL

Monday, 8th November, 1965

Featuring the artistry of

BOB BURGESS and DOREEN FREEMAN

ROBERT CANNON and VIVIEN MILAN

with

Mike Adams and the Mauretania Orchestras

playing Dance Tunes popular from 1939 to 1965

Auld Lang Syne

Should Auld acquaintance be forgot
And never brought to mind,
Should Auld acquaintance be forgot
And Days of Auld Lang Syne.
For Auld Lang Syne, my dear,
For Auld Lang Syne,
We'll tak' a cup o' kindness yet,
For the days of Auld Lang Syne.

⌃ The 'Gala Farewell Ball', 8 November 1965, on the final cruise.

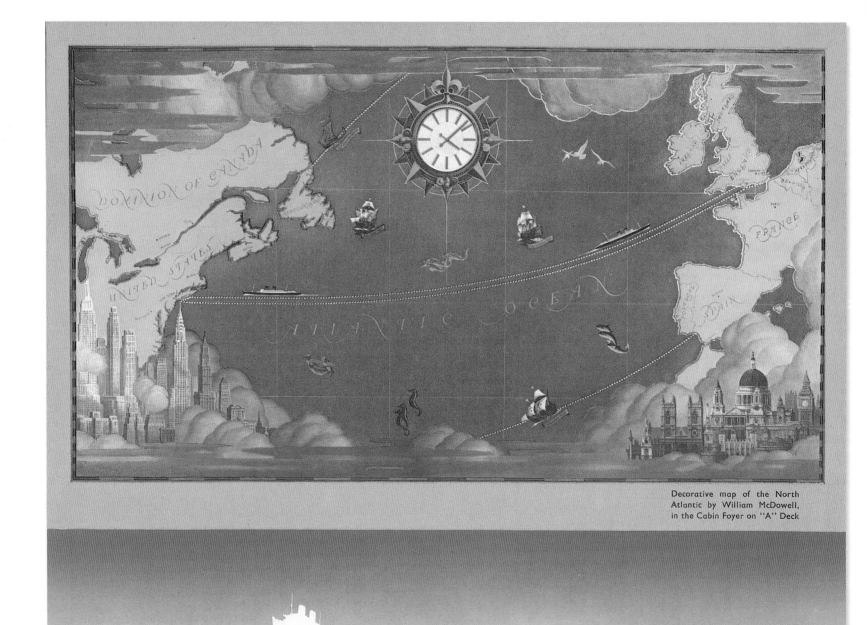

^ The decorative map of the North Atlantic by William McDowell, which was displayed in the cabin foyer on A deck of the *Mauretania*.

Bernard Webb's Certificate of Discharge book and seaman's identification card.

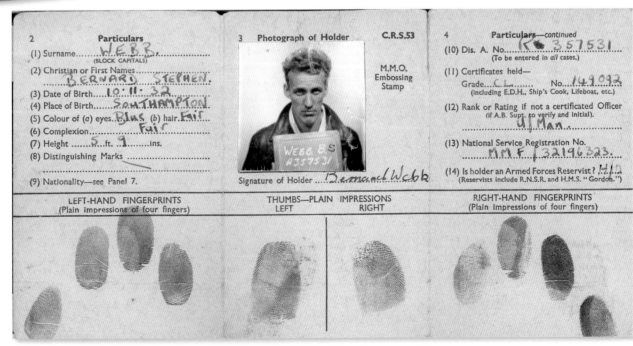

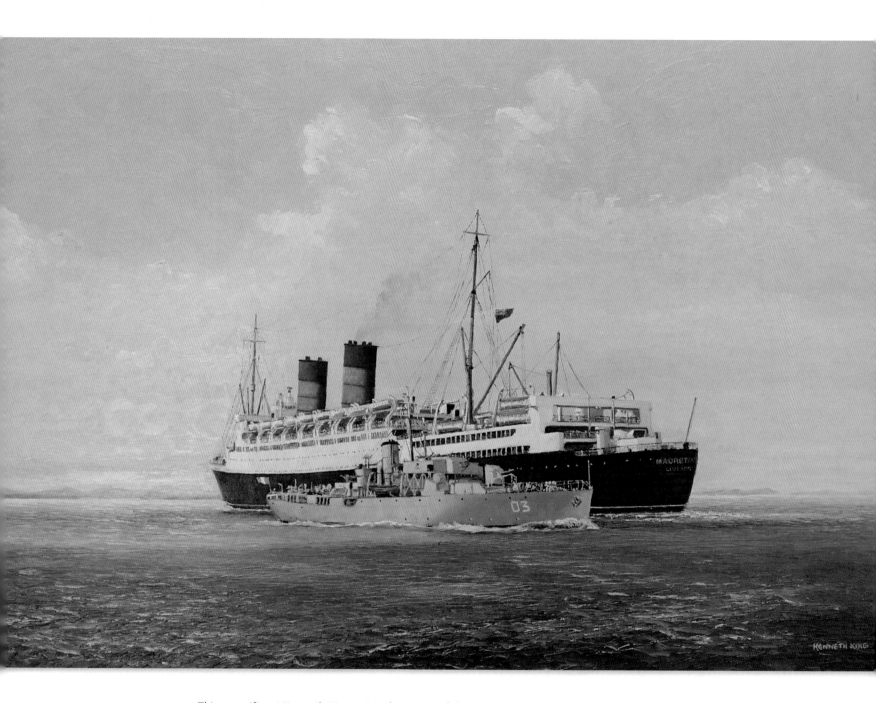

᭢ This magnificent Kenneth King original painting of the *Mauretania* at Cobh in Ireland shows an Irish Navy vessel passing by. The owner of the painting, Oliver Hawes, revealed that both he and his brother spent many happy hours watching the liners, but their favourite ship was the *Mauretania*. (Oliver Hawes, World Ship Society Ireland)